KERBER VERLAG

FUN
CUT

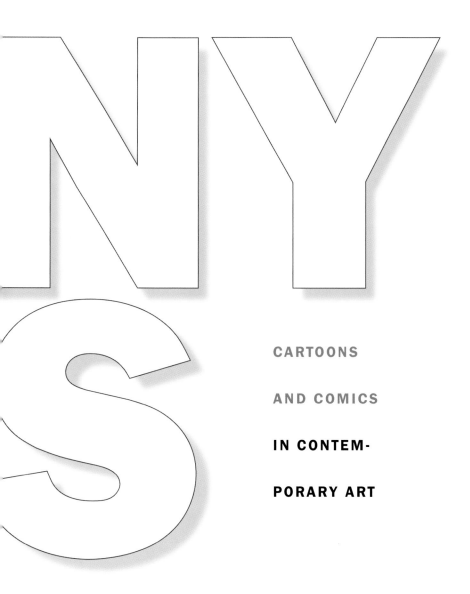

CARTOONS

AND COMICS

IN CONTEM-

PORARY ART

KASSANDRA NAKAS

WITH ESSAYS BY

ULRICH PFARR

ANDREAS SCHALHORN

STAATSGALERIE STUTTGART 2004

FORE-WORD

CHRISTIAN VON HOLST

COMICS HAVE LOST NONE OF THEIR FASCINATION. Today, over a century after the publication of the first of these image–text stories in mass-circulation newspapers in the United States, comics are enjoying renewed popularity. Comic heroes are busy conquering the silver screen in Hollywood films and antiquarian comic books are changing hands for record prices in auctions. Researchers of the world of comics are discussing the birth and reception of the genre in ever more detail – and this includes comics dealing with current events like September 11. And, to top it all, influential »personalities« like Mickey Mouse, Tintin, and Donald Duck have celebrated their 75th and 70th birthdays in recent years – events that attracted a great deal of media coverage. Unquestionably, the medium of comics – its design and content – has changed in many respects over the years. This colourful history forms the backdrop to our exhibition *Funny Cuts*, which highlights the impact the pictorial worlds of cartoons and comics have had on contemporary art.

While recently an increasing number of exhibitions have reflected on the influence of comics on contemporary art (also a sign of the subject's topicality), Funny Cuts has a different and more comprehensive focus. With over a hundred exhibits in a variety of media created by some 40 artists from Europe, North and South America, and Japan, the Staatsgalerie Stuttgart is host to a broad-ranging international and historical panorama of a phenomenon that, despite having prompted startling responses from artists from Pop

Art onwards, has, in Germany, not yet been the focus of a large-scale exhibition dealing with the history and development of this art form. In other words, this exhibition showcases the way artists have tackled the »trivial« and commercial worlds of comic and cartoon images.

The Staatsgalerie houses one of the most important collections of contemporary art in Germany, and here this fascinating phenomenon is being put into historical perspective, while also integrating the most recent trends in contemporary art.

The exhibition focuses on the extraordinary diversity of form and content in the work of artists using comics and cartoons – particularly in recent works – as well as manga and anime from Japan, whose pictorial worlds have also been extremely successful in the West. The exhibition concentrates on the artistic use of the medium of comics, a narrowing of perspective that we hope hard-core comic fans will understand. Due tribute will indeed be paid to comics: through the admiration shown to childhood heroes, for example, in the work of MEL RAMOS, and through the critical and analytical approach to these pictorial worlds, as in the work of ÖYVIND FAHLSTRÖM, and also through the approximation and transformation of the visual language of comics, as in the work of many of the younger artists.

First and foremost, we would like to thank those people who have so generously lent us their works for the duration of the exhibition and so helped to create the exhibition's diversity and scope. Today, Pop Art, too has its incunabula; we are extremely pleased to be able to exhibit some of these indispensable works and are equally grateful to the many, more contemporary, artists who responded to our invitation to take part with spontaneous enthusiasm. YOSHITOMO NARA from Japan, for example, has even created a special pavilion for the Stuttgart presentation of his work, in which visitors can gain a more powerful impression of his subtle drawings. We cordially thank all of the artists involved, and all the people who loaned us pieces of art, not forgetting those who prefer to remain anonymous.

My especial thanks go to my colleague Kassandra Nakas, who devised the exhibition and the catalogue and managed their realisation. She developed, in coordination with Gudrun Inboden, a comprehensive concept encompassing both the history and diversity of media of the subject; this concept covers a spectrum ranging from the atmosphere of artistic upheaval of the late 1950s to the current new upheaval in art: the virtual pictorial worlds of anime, which can essentially be seen as the end point in the exhibition, and also as offering an insight into what is come. It is particularly fortuitous that the Sohm Archive of the Staatsgalerie contains significant Situationist International and Concrete Poetry materials; their critical interpretations of comics have not, to date, been

shown due consideration. The inclusion of these materials confirms the broad conceptual basis of the exhibition.

While the keynote essay by Kassandra Nakas provides an in-depth introduction to the themes covered in the exhibition, the two further essays examine specific issues in detail. During his period as head of art education at the Staatsgalerie, Andreas Schalhorn, now at the Kupferstichkabinett in Berlin, first proposed the exhibition. In his article, he addresses the role of the line in drawing and painting after the emergence of comics. Ulrich Pfarr, in contrast, provides an insightful appreciation of the mythological potential of comics; this essay concluded his time as assistant curator at the Staatsgalerie. I would like to take the opportunity to express my appreciation to both of these latter authors for their stimulating contributions to this project.

I would also like to express my thanks for the dedicated commitment of the many teams working in the Staatsgalerie: they ably supported and assisted Kassandra Nakas in ensuring the success of the exhibition. Finally, I would like to especially thank the Stiftung Landesbank Baden-Württemberg for again providing generous financial support.

FUNN
CUTS

THE WORLDS OF

CARTOON AND

COMIC IMAGES

IN CONTEMPORARY ART

KASSANDRA NAKAS

»THE COMICS ARE A SPECIAL MASS ART. ›SOME-
THING THAT IS NEITHER FILM NOR SERIAL STORY,
NEITHER THEATER NOR CARTOON, BUT WHICH
HAS MONTAGE, SERIAL ACTION, PERIPETEIA AND
VISUAL POIGNANCY‹ — IT SOUNDS LIKE A RIDDLE,
AND MAYBE IT IS. [...] THE COMICS ARE A UNI-
QUE ART.« ÖYVIND FAHLSTRÖM[1]

THE LINKS BETWEEN the visual arts and the medium of comics have been many and di-
verse since the latter first saw the light of day at the end of the 19th century. The first
sophisticated image–text stories were created during the early commercial heyday of
comic strips about a century ago. These were representative of the artistic and produc-
tive interaction between the »low« and »high« forms of expression that created the spec-
tacular works of Pop Art and set the art world in motion over 50 years later.[2] WINSOR

MCCAYS *Little Nemo in Slumberland* (1905) took its cue from the aesthetics of Art Nouveau, the painter LYONEL FEININGER created *Kin-der-Kids* (1906) and the surreal scenarios of GEORGE HERRIMAN'S *Krazy Kat* (1911) were later paraphrased by ÖYVIND FAHLSTRÖM and other artists.

The »revolutionary« 1950s and 1960s are also a starting point for our consideration of the critical enquiry of artists into the pictorial worlds of cartoons and comics. This appropriation of comic motifs and structures has always been fragmentary, and certainly subjective, as is shown in the title of this exhibition: *Funny Cuts*. This title alludes to an early US comic strip and was chosen as it highlights the diversity of the references made by contemporary artists to the content and form of the pictorial cosmos of comics; references, which can be humorous, anarchic, or socio-critical and constitute a parallel reality in which individual or social themes can be addressed in fiction.

Given the great diversity of current artistic forms of expression, which the exhibition presents against the background of art since the 1950s, it soon becomes apparent that in recent years (not least thanks to the impact of its Japanese counterpart, the manga) the medium of the comic has once again attracted the attention of artists.

POP ART: THE CONFRONTATION OF HIGH & LOW

RICHARD HAMILTON — EDUARDO PAOLOZZI — PETER BLAKE

In **RICHARD HAMILTON'S** *Just what is it that makes today's homes so different, so appealing?* from 1956 (fig. right), the visual language of the comic – a fragment of a consumer-oriented reality – forces its way into the unity of the image. This small collage, which Hamilton made for the London show entitled *This is Tomorrow* (which had a strong focus on cultural sociology) became an incunabulum of Pop Art. It presents the paper-based materiality of the comic in a frame: the »pictorial waste« of popular culture ousts the traditional panel painting. The front page of *Young Romance*, as visual raw material, stands at the centre of this sobering vision of contemporary life: technological achievements and the world of commodities seem to have lead to isolation and emotional hypothermia; the melodramatic parallel world of the comic promises some compensation, although here, too, suppressed emotions prevail: »We've got to keep our love a secret, Marge…«.

RICHARD HAMILTON
Just what is it that makes today`s homes so different, so appealing?
1956
Kunsthalle Tubingen, Collection Zundel
CAT. 28 »

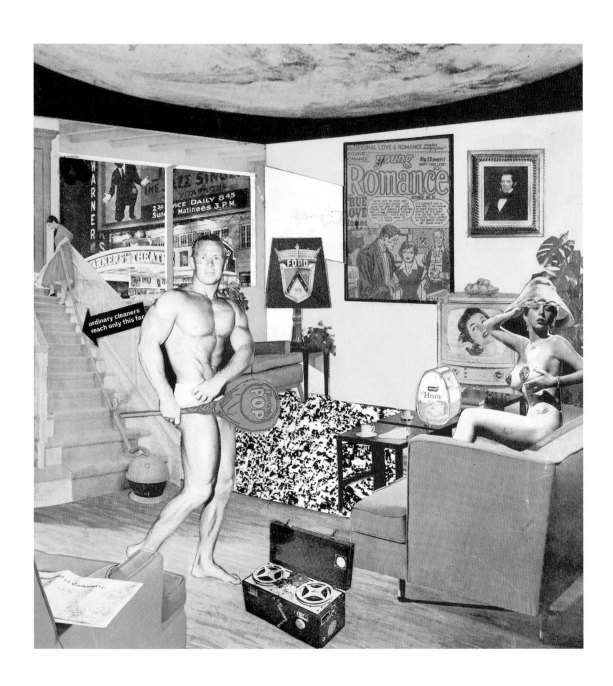

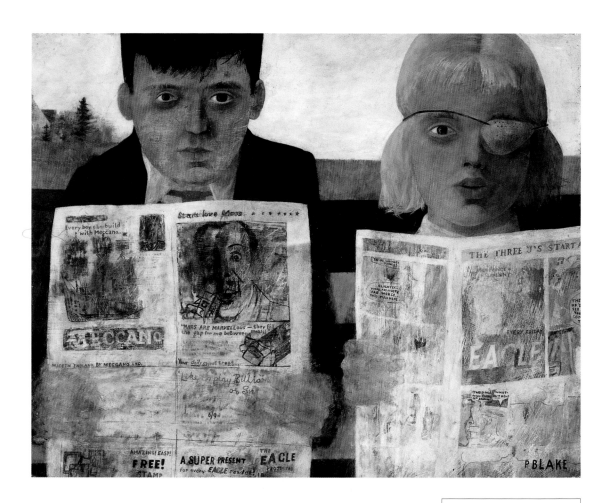

PETER BLAKE
Children Reading Comics
1954
Tullie House Museum and Art
Gallery, Carlisle
CAT. 12

Hamilton called for artists to »plunder the popular and trivial arts« and thus ensure a »constant enrichment of visual material«.[3] Similarly, **EDUARDO PAOLOZZI** who was also connected to the British »Independent Group« had, since the 1940s, pursued the goal of assembling a comprehensive collection of the images of trivial culture. His collages were published in a portfolio of prints called *Bunk* in 1972, and attest to his fascination with the visual resources provided by (primarily US) consumer society: (figs. below) magazines, pulp fiction, advertisements and comic books, whose comparatively simple compositions reveal less of a critique of society and more of an affirmative impulse, while equally seeming to provide evidence for the »Americanisation« of Europe criticised in many quarters.

EDUARDO PAOLOZZI
Bunk: Real Gold
1950/72
Staatliche Museen zu Berlin,
Kupferstichkabinett
CAT. 48 A

Bunk: Meet the People
1948/72
Staatliche Museen zu Berlin,
Kupferstichkabinett
CAT. 48 B

In 1954, reservations against comics, which were usually imported from the United States and very popular with children, were legitimated by the introduction of the code established by the US Comic Magazine Association, which set down strict rules on form and content, and favoured public morality and »good taste«. In **PETER BLAKE'S** painting from the same year *Children Reading Comics*, (fig. p. 14) however, these have not lost any of their fascination as a formative childhood cosmos of images and stories. The comics are positioned in the foremost section of the picture, and thus dominate; the strangely staring children

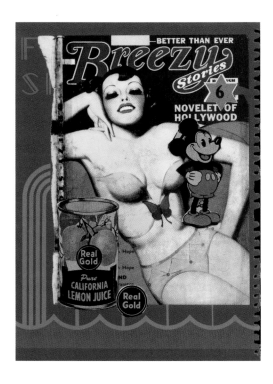

seem to proffer the comics; the viewer directly experiences the suggestive power of the comic books upon the small and limited world of the children. The unfinished painted sections of the comics – one shows the British adventure comic *Eagle* – have a fleeting, damaged sense to them, containing even a sense of nostalgia.

MEL RAMOS – ANDY WARHOL – ROY LICHTENSTEIN

MEMORIES FROM HIS OWN CHILDHOOD during the 1940s heyday of US comics inspired the artistic references to superheroes in the work of the Californian **MEL RAMOS**.[4] The broad, pastose brushstrokes of *Batman* (1961), *Captain Midnight* (1962) and *The Flash* (1962) (figs. right, p.18, 113) attest to Ramos' artistic roots in Abstract Expressionism; the isolated, heraldic presentation of the costumed heroes from his childhood against a monochrome ground is characteristic.[5] The pastose application of paint corresponds to the physical presence of the figures shown, who confront us head-on and almost leap out from the canvas either at superhuman speed (*The Flash*) or through the use of trompe-l'oeil (in *Captain Midnight*, the cartridge belt reaches out of the tondo frame). The direct appeal of the work to the viewer shows, to some extent, the emotional potential these figures still possess, even beyond their adventure cosmos, and also their function as a screen onto which adolescent wishes and dreams can be projected.

From the same period, but apparently independent of both Ramos and Roy Lichtenstein, **ANDY WARHOL** similarly chose specific characters from the repertoire of comics for a small selection of pictures, his first works as a painter after his times as a successful commercial artist. His protagonists are Batman, Superman, Popeye, and Dick Tracy the first comic-strip detective; (fig. 1) in stylistic terms they are very different from Warhol's earlier illustrations and from the silk screens that later shaped his entire oeuvre, which he started working on shortly afterwards. Warhol once stated that when he first

MEL RAMOS
The Flash
1962
Mel Ramos
CAT. 67

》

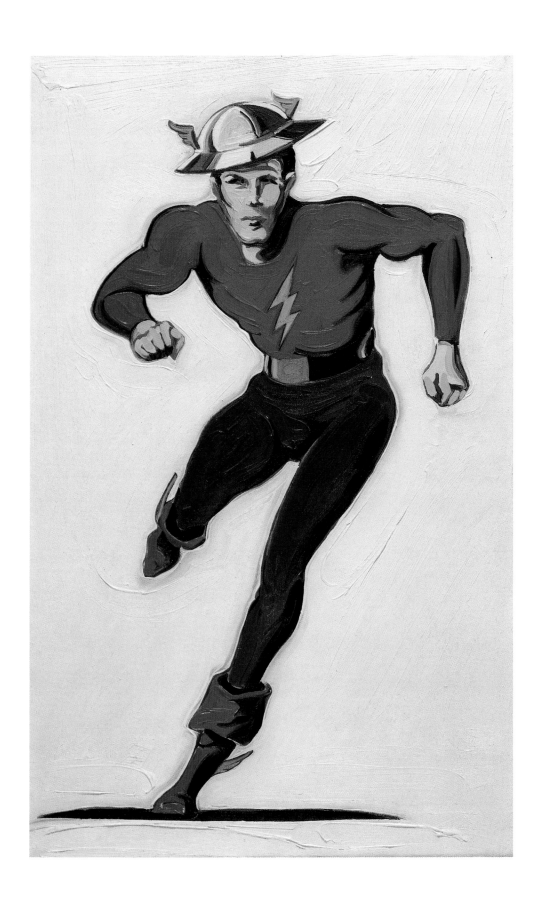

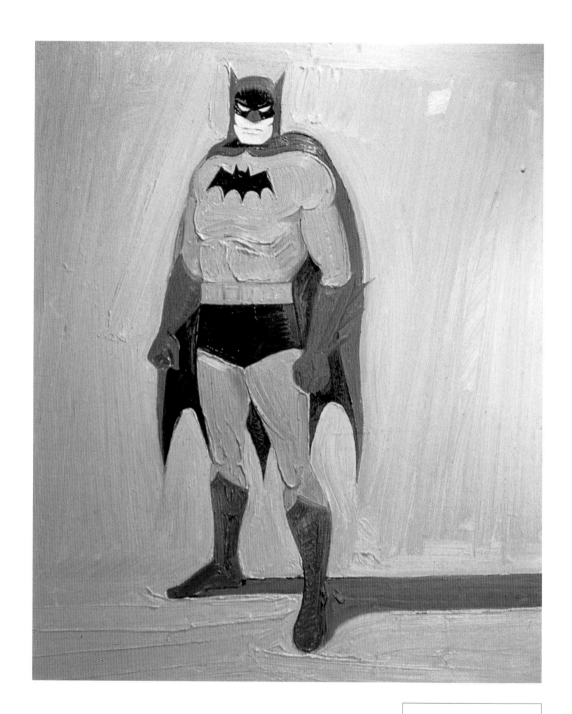

MEL RAMOS
Batman
1961
Mel Ramos
CAT. 68

saw the work of Roy Lichtenstein using comic motifs, he immediately downed tools and abandoned his own work with comics.[6] If we attach any credence to a more recent interpretation, then these idiosyncratic tributes to the masculine comic idols of his youth also offered him an artistic means of expression commensurate with his »queer« personality.[7]

In the paintings and prints he began in 1961, **ROY LICHTENSTEIN**, in contrast, concentrated on individual panels from »anonymous« comics, which depict highly dramatic scenes, usually from a war-related or romance genre (figs. p. 83, 88, 89).[8] The comparison of *Takka Takka*, from 1962, (fig. p. 21) with the original underlying panel (fig. 2) reveals that Lichtenstein substantially altered the panel, which he projected onto the canvas using a slide. The use of a wider format, the choice of a close-up detail, and the larger text elements make the pictorial motif appear more compressed, and the elimination and addition of individual details also serve to create a far more dramatic effect than in the original image. On the other hand, the changes to the content and form of the caption generate a more cohesive image–text entity and make it easier to read in general. To this extent, in comparison with the original panel, which has been removed from its narrative context, a trend towards a more »classical« form of painting, and aestheticisation, can be discerned in the Lichtenstein piece. This, unsurprisingly, led to the accusation from comic illustrators that he had »betrayed« the

ANDY WARHOL
Superman
1961
private collection
FIG. 1

The success story of the US SUPERHERO COMICS started with the launch of COMIC BOOKS in the mid-1930s. *Superman* (from 1938) was the model for countless superheroes; these were soon being marketed in a range of media (animated cartoons, newspaper comic strips, and radio shows). The boom in superhero comics, which led to the »Golden Age« of the medium in the USA, was also thanks to social and political conditions in the 1930s and 1940s. The »Golden Age of Comics« came to an abrupt end in 1954 with the introduction of the Comic Code Authority (CCA). This code subjected comics to harsh censorship in order to protect the rights of minors. In contrast, the same decade saw the blossoming of comic production in Europe.

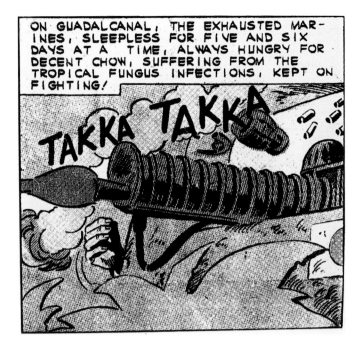

medium.[9] The act of appropriating existing comic motifs, typical of the work of many creators of Pop Art, is thus especially striking in Lichtenstein's work; and was especially controversial in his case because of his fundamental transformation of the form, function and content of the original fragments of an image–text narrative.

JOHN WESLEY – WILLIAM COPLEY

THE WORKS OF US artist **JOHN WESLEY** also show a definite tendency towards the stylistic transformation of artwork from comic strips. A former illustrator, since the 1960s, he has used a small selection of comic strips, as well as photographs and original images. His human figures and animals are always portrayed in an extremely stylised manner: pronounced black outlines frame large-scale monochrome surfaces; motif symmetries and repetitions and a reduced pastel palette exaggerate the graphic features of the comic and create a formal rigour that, in works such as *B's Town*, 1973/74 (fig. p.23) and *Olive Oyl*, 1973 (fig. p.22) contrasts sharply with the »cuteness« of the motifs. In both of these works, Wesley refers to two family strips that have been extremely popular in the United States since the 1930s: *Blondie* and *Popeye*.

While Blondie and her husband Dagwood Bumstead, whose dog Daisy puts in an appearance in B's Town, constitute a typical US middle-class suburban family, Popeye, Olive Oyl and their baby Swee'pea are grotesquely exaggerated outsiders. Both Blondie and Popeye, however, deal with stereotypes that have survived unchanged for decades; one of the themes of the everyday lives of these characters is the (unequal) relationship between the sexes. In the 1930s and 1940s, the extraordinary popularity of the strips led to unauthorised copies known as Tijuana Bibles or Dirty Comics: parodies that added a

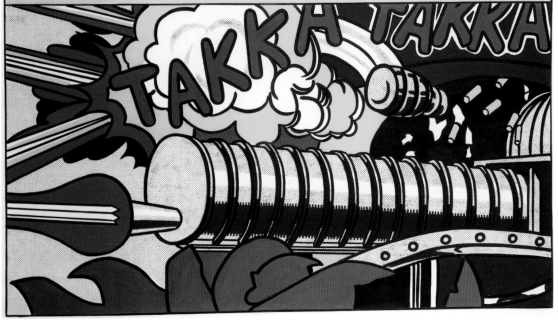

ROY LICHTENSTEIN
Takka Takka
1962
Museum Ludwig, Cologne
CAT. 38

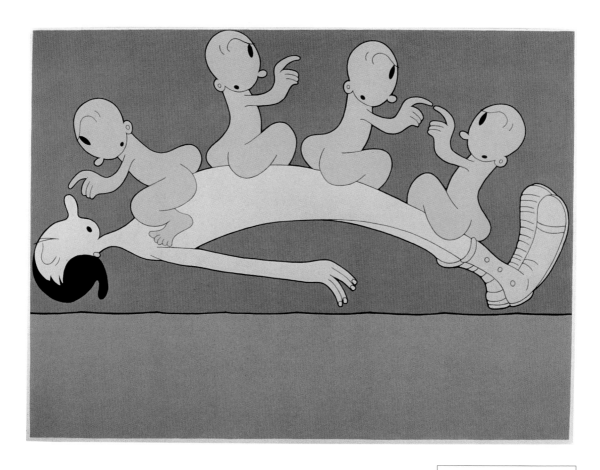

JOHN WESLEY
Olive Oyl
1973
private collection, Switzerland
CAT. 96

range of sex scenes to the original comics, and which, because of their subversive nature, can be considered precursors of the underground comics of the 1960s.[10] However, our familiarity with the comic characters is undermined in Wesley's paintings; here they become alienated and uncanny. Daisy the dog seems strangely lost in an anonymous scene bereft of any people, and the characteristically long skinny body of Olive Oyl, here naked, seems to be floating. Four beings in the guise of her baby Swee'pea sit on her ostensibly sleeping body like nightmarish monsters. The nakedness of the figures, their mother–child relationship, and, not least, the subconscious and dream-like aspects imbue the work, for all its carefree tone, with an existential dimension.

A sexual motif, similar to that which runs beneath the surface of Wesley's depiction of a naked Olive Oyl, is encountered in a far more explicit form in the works of the US artist **WILLIAM COPLEY**. In his paintings and drawings, (fig. p.24) a striking black outline also plays a key role. Using a reduced vocabulary of form and a stylistically consistent repertoire of figures (a man in suit and hat, a naked woman) Copley essentially always tells the same erotic stories, all lacking any moral component and usually, influenced by his artistic roots in the realm of Paris Surrealism, consciously flout breach bourgeois »decency«.

JOHN WESLEY
B's town
1973/74
Collection Onnasch
CAT. 97

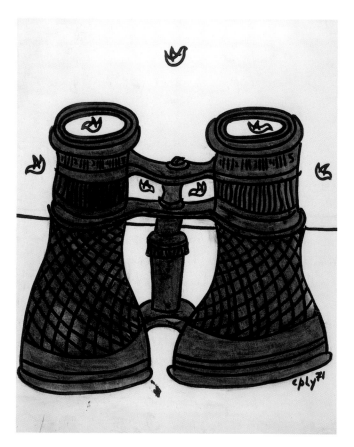

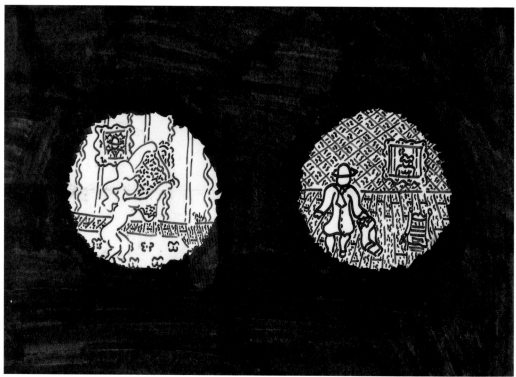

Pictorial narrative is also the defining feature of the works of Hervé Télémaque and Erró, who, in the mid-1960s in Paris, referenced a broad range of visual sources, such as comic strips, magazine photographs, advertising, and film stills – while endeavouring to disassociate themselves from the stance taken by US Pop artists, whom they considered »formalist«.

The Haitian **HERVÉ TÉLÉMAQUE**, who arrived in Paris in 1961 via New York and sampled the final phase of Surrealism in the French capital, experienced the change of direction towards narrative figuration as an opportunity to say something about his identity by referencing everyday objects in the world around him: »That is the aim of any artist: to set out his alphabet, a rhetorical system, signs which become increasingly significant in terms of his life and thoughts«.[11] Thus, *One of the 36 000 Marines over our Antilles*, from 1965 (fig. S.26/27) refers to a real event of that year: the US military intervention in the Dominican Republic. However, Télémaque did not produce an inflammatory denouncement of US imperialism in the age of the Cold War; rather, he combines the central motif of the soldier, taken from a photograph, with numerous other pictorial motifs. The cartoon-like man at the table, the woman's head in Pop Art style, items of male clothing, a car, a tulip, birds and stencilled writing alluding to French history (like Haiti, the Dominican Republic was once a French colony) do not have any obvious connections to each other. Only the style of painting, with its reduced sharp outlines and large monochrome areas, ensures the coherence and unity of the large-format composition. In earlier works, Télémaque made use of actual figures from the pictorial cosmos of Disney comics, while in this work he references the Belgian Hergé, generally considered to be the most influential illustrator of comics in Europe. The clarity of the composition is achieved through the use of the ligne claire style

»I ALWAYS SAY THAT MY SIMPLIFYING SURROUND, WHICH ENABLES ME TO TAKE HOLD OF A SHAPE QUICKLY, COMES A LITTLE FROM MATTA, LAM AND PICASSO, CERTAINLY, BUT IT'S CLOSER TO HERGÉ THAN FERNAND LÉGER.« HERVÉ TÉLÉMAQUE[a]

[a] »Hervé Télémaque: Interview with Jacques Gourgue«, in: *Télémaque*, exh.cat. IVAM Centre Julio González, Valencia 1998, p.157.

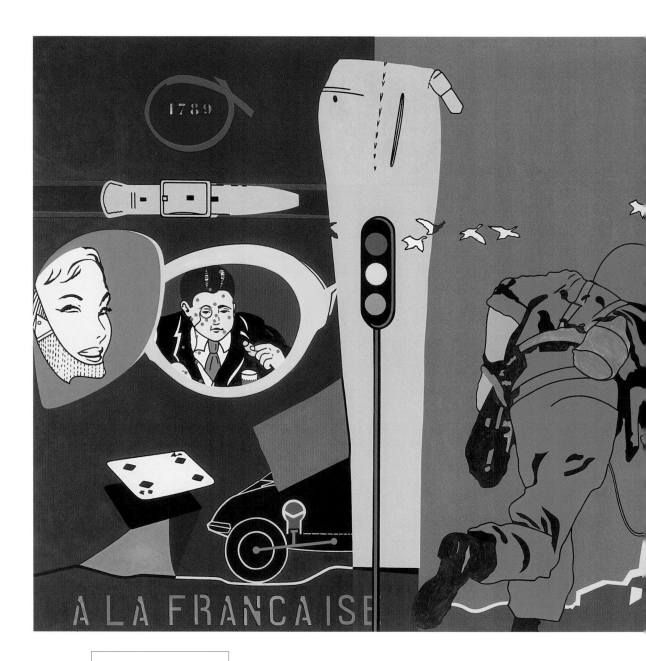

HERVÉ TÉLÉMAQUE
One of the 36000
Marines over our Antilles
1965
Courtesy Kunstverein
Braunschweig
CAT. 95

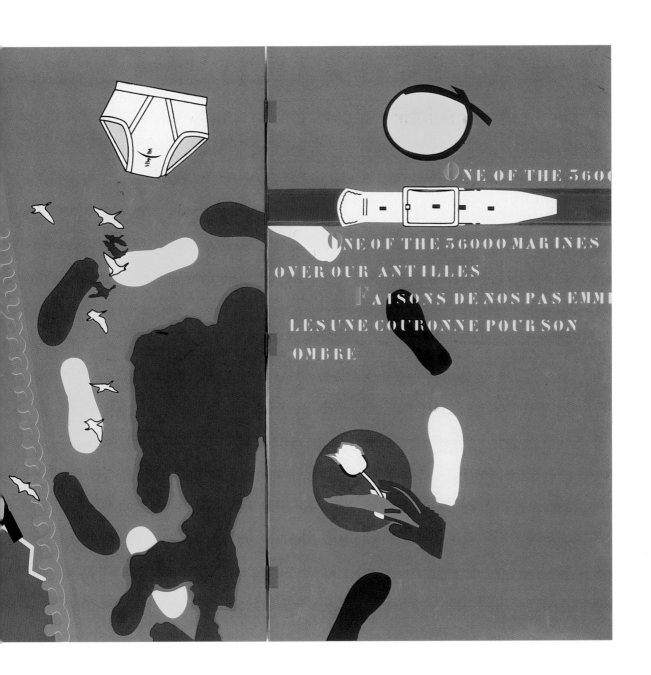

ONE OF THE 3600

ONE OF THE 36000 MARINES
OVER OUR ANTILLES
FAISONS DE NOS PAS EMM
LES UNE COURONNE POUR SON
OMBRE

(which was pioneered by Hergé, the creator of Tintin). This collides in Télémaque's painting with the bold combination of everyday objects, which, in their isolation, somehow appear »magical«. This reaction to an actual event in recent history leads here to a highly subjective poetic narrative that is filled with associations.

There is a similar expectation in the work of the Icelandic artist **ERRÓ**, to that of Télémaque: art should have a critical function. He draws on the entire gamut of existing mass-media images. Usually, he concentrates on an analysis of these images as (manipulated and manipulating) intermediaries of contemporary events, but also emphasises the overkill of visual stimuli in a consumer society, for example, in *Comicscape* from 1972, (fig. p.110/111) a typically collage-like work comprising of an encyclopaedic collection of diverse comic characters. The characters, for the most part anchored in our collective memory of images, constitute their own, seemingly endless, cosmos, which, in the upper edge of the picture, is backgrounded by an exploding universe. However, this pandemonium of joyful anarchy avoids the biting satirical undertone frequently to be found in Erró's critical painted collages. Rather, it reflects French enthusiasm for bandes dessinées, which, because of their influence on the art of narrative figuration, had already found their way into the museum in 1967.[12]

COMICS AS SUBVERSION

ÖYVIND FAHLSTRÖM – GIANFRANCO BARUCHELLO – MATT MULLICAN

ERRÓ FIRST FOCUSSED seriously on the pictorial world of comics during his trip to New York in 1962; there, his artist friend **ÖYVIND FAHLSTRÖM** introduced him to the protagonists of US Pop Art, among others.

Fahlström was a writer and critic – in 1954, he published his *Manifesto for Concrete Poetry* and the article *The Comics as an Art* – and was wellversed in the ideas of Dadaism, Surrealism, Lettrism, and Concrete Poetry. The notion of the materiality of language that is prevalent in these ideas was a formative influence on his interest in the visual worlds of comics. He believed it was necessary to liberate comics from their set stereotypes, to refine them down into their constituent parts, and give them a new form: »It is always a matter of reshaping material and not allowing oneself to be reshaped by it«.[13] He was already using this dissectory approach in the early 1950s, when he deconstituted his source materials, for example, *Mad magazine*, to such an extent he was able to assemble an abstract span of images (fig. 3). When he moved from Paris to New York in 1961, the visual material of comics increasingly became a basis for his critical inquiry into cur-

ÖYVIND FAHLSTRÖM
The Cold War
1963–65
Detail
Musée national d'art moderne,
Centre Georges Pompidou,
Paris
CAT. 27

》

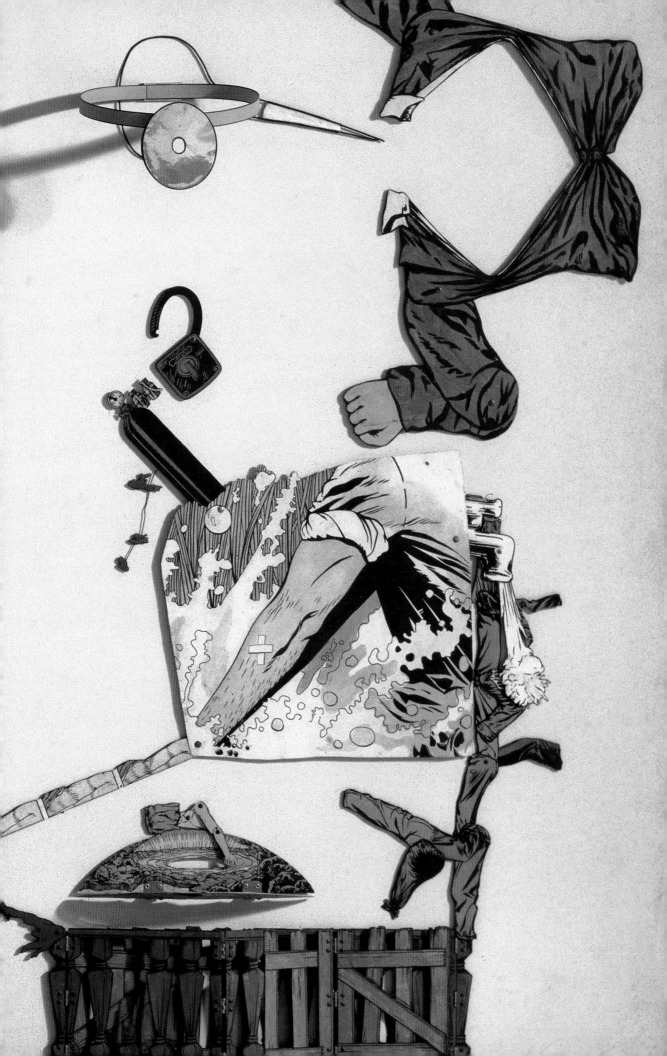

GIANFRANCO BARUCHELLO
La Correspondence
1976
Städtische Galerie im Lenbachhaus,
Munich
CAT. 11

rent social and political conditions and their representations. He questioned the »domination of images« in variable tableaux such as *The Cold War*, from 1963–65 (fig. p.36). Here, the viewer is challenged to change the structure on offer: fragments from comics, in the form of magnetic elements, are placed on a board and so can be constantly re-assembled to create new arrangements and images. The familiarity of the comic images may make the viewer aware of his or her manipulative position and raise consciousness that active intervention on our part not only changes our image of the world, but also the world itself.

In the early 1970s, in what became known as his *World Maps*, Fahlström created his own cartoon-like symbolic language in order to visualise contemporary and political facts in a reduced, readily comprehensible form. Through the narrative structure of the image–text sequences, their anarchic impetus, and expressive easily understood language of form, he transformed key characteristics of comic strips into an individual and original visual language that treads the thin line between the fine arts and literature.

ÖYVIND FAHLSTRÖM
Feast on Mad
1957–59
Musée national d'art moderne,
Centre Georges Pompidou,
Paris
FIG. 3

The fragmentation of found image and text material (comic strips, advertisements, literature) is also typical of the work of **GIANFRANCO BARUCHELLO**, who was a friend of Fahlström. However, he subjects the material to a radical process of reduction and, painting with cartoon-like simplicity,

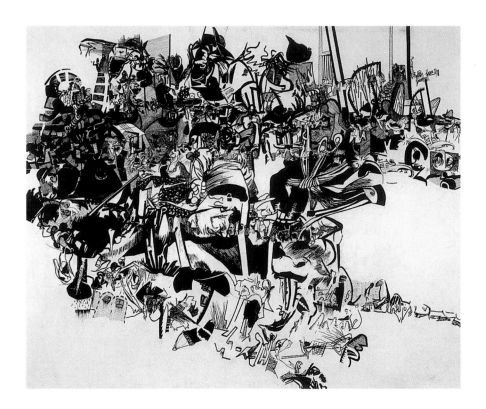

A **CARTOON** tells an illustrated story in one or a small number of pictures, often without any descriptive text. In the 20th century, the »cartoon« has established itself as the generic term for all types of illustrated humour.

shapes it into a quasi-narrative sequence, which is barely legible because of its minute detail and open structure. In the same way, *La Correspondence*, from 1976, (fig. p.30), uses countless small-format, abstract and figurative pictorial elements to tell the (largely) incomplete story of an exchange of letters. The vertical composition undermines the act of reading from the left to right; horizontal arrows suggest semantic references that are incomprehensible. The associative arrangement of the pictorial and textual elements on the aluminium panel has a subjective and variable feel that is similar to the varied arrangements of Fahlström's *The Cold War.*

During the same period, the young artist **MATT MULLICAN** pursued a quite different strategy of fragmentation during the same period; in *Details from an Imaginary Universe*, 1973 (fig. p.34) he deconstructs the pictorial worlds of comic strips into cutouts from a fictitious world, which he endeavours to appropriate as an exemplary reality. Throughout his entire oeuvre, and using diverse media, Mullican tries to find a systematic form for his subjective experience of reality and, to this end, designs a kind of sign system with which he reconstructs this reality. It is because the pictorial units and surfaces have been broken down that the artist can experience the illustrated world of the comic strips as a (fictitious) space and as an »imaginary universe«. He himself comments: »It is a kind of a submerging aspect. And I used to call the place the ›imaginary universe‹ and a ›fictional reality‹ [...]«.[14]

INTERNATIONALE SITUATIONNISTE

est le minimum de la construction des situations. » Kotányi propose d'envisager ce plan dans des limites définies, et donc des limites de temps : une planification du temps nécessaire pour installer ce réseau minimum ; qui se subordonnerait les autres instruments situationnistes, y compris l'appareil de sa propagande, de ses publications.

La discussion de ces perspectives conduit à poser la question : Dans quelle mesure l'I.S. est-elle un mouvement politique ? Diverses réponses affirment qu'elle ne voit en dehors d'elle que des sous-politiciens. Le débat atteint une certaine confusion. Debord propose, pour dégager nettement l'opinion de la Conférence, que chacun réponde par écrit à un questionnaire demandant s'il estime qu'il y a « des forces dans la société sur lesquelles l'I.S. peut s'appuyer ? Quelles forces ? Dans quelles conditions ? » Ce questionnaire arrêté et rempli, la lecture des premières réponses fait apparaître que l'I.S. entend établir un programme de libération d'ensemble, et agir en accord avec d'autres forces à l'échelle sociale (Kotányi) : « S'appuyer sur ce que nous appelons libre. » – Jorn : « Nous sommes contre la spécialisation et la rationalisation, mais non contre elles en tant qu'instruments... les mouvements des groupes sociaux sont déterminés par le caractère de leurs désirs. Nous ne pouvons accepter d'autres mouvements sociaux que dans la mesure où ils tournent dans notre sens. Nous sommes la nouvelle révolution... pour agir avec les au-

tres organisations qui, en dehors de nous, cherchent la même voie. ».
La séance est levée alors.

Au début de la seconde séance, le 26 septembre, Heinrard Prem lit une déclaration de la section allemande en réponse au questionnaire. Rédigée à l'issue de la séance de la veille, cette déclaration, très longue, attaque dans les réponses exprimées la veille la tendance au studieu d'un prolétariat révolutionnaire, car les signataires doutent fortement des capacités révolutionnaires des ouvriers contre les entreprises bureaucratiques qui ont dominé leur mouvement. La section allemande estime que l'I.S. doit s'apprêter à réaliser seule tout son programme, en mobilisant les artistes d'avant-garde, la société actuelle place dans des conditions intolérables, et qui se peuvent compter que sur eux-mêmes pour s'emparer des armes du conditionnement. Debord répond par une vive critique de ces positions.

Une séance de nuit reprend l'examen de la déclaration allemande. Nash s'efforce d'en affirmant la capacité de l'I.S. d'agir immédiatement sur le terrain des organisations sociales et politiques. Il préconise l'organisation systématique de l'infiltration d'éléments situationnistes clandestins partout où ce sera utile. Nash est approuvé, en principe, par tout le monde, avec diverses réserves circonstancielles. Cependant, le débat sur les positions allemandes ne cesse d'être relancé, ramené à son noyau central : l'hypothèse des ou-

26

vriers satisfaits. Kotányi s'adresse aux délégués allemands pour leur rappeler que si depuis 1945, ils ont vu en Allemagne des ouvriers apparemment passifs et satisfaits, et les grèves légales organisées avec de la musique pour distraire les syndiqués, dans d'autres pays capitalistes avancés, les grèves « sauvages » se sont multipliées. Il ajoute qu'à son avis, ils méconnaissent profondément l'ouvrier allemand lui-même. Jorn répond à Prem, qui a fait une distinction entre questions spirituelles et matérielles, qu'il faut en finir avec cette distinction, qu'il faut « que les valeurs matérielles reprennent une importance « spirituelle », et que les capacités spirituelles soient valorisées seulement à travers leur matérialisation ; en d'autres termes, que le monde devienne artistique *au sens défini jusqu'à ce jour par l'I.S.* ». Jacqueline de Jong demande que, pour simplifier une discussion devenue obscure, et compliquée encore par certaines traductions (la langue dominante de la Conférence est l'allemand), chacun déclare s'il approuve ou non la mise au point de Jorn. Tous y souscrivent. Sur les thèses allemandes, Debord propose que la majorité annonce ouvertement qu'elle les réprouve. On s'accorde alors pour que les partisans exclus de l'I.S. et plus récemment séparément leur position. La minorité allemande se retire pour délibé-

rer dans une pièce voisine. Quand elle rentre en séance, Zimmer annonce, au nom de son groupe, qu'ils retirent la déclaration précédente, non parce qu'ils pensent qu'elle est dépourvue d'importance, mais pour ne pas freiner maintenant l'activité situationniste. Il conclut : « Nous déclarons nous identifier avec tous les actes déjà faits par l'I.S., avec ou sans nous, et à ceux, qui se feront dans tout l'avenir prévisible. Nous sommes aussi d'accord avec toutes les idées publiées par l'I.S., en réservant l'avenir de la discussion d'aujourd'hui, que nous considérons comme secondaire par rapport au développement d'ensemble. » Tous acceptent. Cependant Kotányi, puis Debord, demandent que l'on inscrive qu'ils n'estiment pas que la question discutée aujourd'hui soit secondaire, d'accord pour supprimer cette dernière phrase. La séance est levée, très tard dans la nuit.

Une sortie de la British Sailors Society.

La quatrième séance, du 27, adopte une résolution sur l'emprisonnement d'Alexander Trocchi ; et

21

INTERNATIONALE SITUATIONNISTE

pensée. Le milieu culturel, même dans ses nuances les plus modernistes et bienveillantes, va donc en même temps favoriser le maximum de confusion sur la réalité de l'I.S. (brutalement : les explique se manquent jamais aux entreprises nashistes) ; nous traiter plus ouvertement encore en réprouvés (comme c'est apparu avec le grand nombre de gens qui ont refusé de défendre Uwe Lausen avant son emprisonnement, alors que les mêmes avaient pris la défense des exclus de la section allemande de l'I.S., pourtant/ls pour le même délit de presse ancien) ; et particulièrement essayer d'organiser un étouffement économique renforcé.

Dans ce courant, le détail nashiste actuel n'est qu'un épiphénomène. Ses successeurs seront sans doute plus forts. Les Nash sont interchangeables : ils représentent notre antagonisme avec le vieux monde artistique. L'évolution du nashisme, depuis le détail que la section scandinave publie maintenant la revue *Situationistisk Revolution*, les nashistes ont retrouvé très vite ce qu'il y a de plus traditionnel dans les mours du milieu artistique, c'est-à-dire d'une part les marchandages et petits fours des vernissages, d'autre part, la salade bonasserie de l'I.S. - Ecole des Beaux-Arts ». Nash a fait savoir aux journaux que, parmi les partisans exclus de l'I.S., il plus récente était Ambrosius Fjord, qui n'arrivait pas

à comprendre les raisons de le malheur. En effet, Ambrosius Fjord ne serait autre qu'un cheval appartenant à Nash, qui aurait mis jour son nom sous une proclamation quelconque, parce qu'il manquait Norvégien représentatif pour que nashisme scandinave fût au comp

Jørgen Nash, face et profil.

Est-ce un exemple de la fameuse règle du pouvoir absolu qui corrompt de traduisa du mouvement et de la théorie révolutionnaire qu'a resté le premier dans son village suite de son pronunciamento, Ca Nash a fait de son cheval un situationiste. Attendons la procha trouvaille : il prétendra que son cheval était en plus membre du Con Central de l'I.S. ; il a déjà exa quelque chose de ce genre avec l'I.S.7, page 34). Le nashisme est a tellement tourné vers le passé, que seul effort d'imagination des

DÉFINITION
adoptée par la Conférence d'Anvers, sur le rapport de J. V. Martin

Nashisme : terme tiré régulièrement du nom de Nash, auteur qui sem avoir vécu au Danemark au XX° siècle. Principalement connu pour sa tentat à un son nom détourné par ce mouvement comme terme générique applica à tous les [genres] dans les luttes engagées contre les conditions dominan de la culture et de la société. Exemple : « Le nashisme cependant a passé maître en soir, ainsi que l'hoche des champs ». Allemand : nashismus. Anglai nashism. Italien : nascismo. Nashiste : partisan de Nash, ou de sa doctrin Par extension, ce qui relève, dans la conduite ou l'expression, des intentio ou de l'allure du nashisme. Nashistique : doublet populaire, probablement attraction de l'adjectif anglais nashistic. Nashisterie : généralement, milieu social du nashisme. L'argot nashistoque est vulgaire.

32 FUNNY CUTS

IN THE 1950S, Richard Hamilton and Eduardo Paolozzi »plundered« the comic strips' stock of trivial images for their collages, confronting these images with the traditional concept of the picture and so dragged the world of fine arts into the contemporary technological world of consumerism. At the same time, the **SITUATIONIST INTERNATIONAL** was another European movement that followed the goal of pulling down the divisions between art and life much more radically. The Situationist International was founded in 1957 by Guy Debord and others, and its declared Dada-influenced intentions included a radical re-interpretation of social and political values; its central strategies included »détournement«, the »creative appropriation and reorganisation of existing elements«, and their de- and recontextualisation in new, alien settings.[15]

Comic strips are a popular object of this aesthetic strategy of »misappropriation«: they appear as a highly suitable medium of collective and socially relevant expression thanks to their ready accessibility and explicitly non-art status. In addition to the »détournement« methods –quoting from unnamed sources or giving new titles to images from advertisements – the decontextualised comic strip panels, whose word balloons have been changed, are characteristic of many of the Situationists' publications, includ-

GUY DEBORD
internationale
situationniste
1958–69
no. 5 (Dec. 1960),
no. 8 (Jan. 1963),
no. 10 (March 1966),
ed. by l'internationale
situationniste
Staatsgalerie Stuttgart,
Archiv Sohm
CAT. 17 A–C

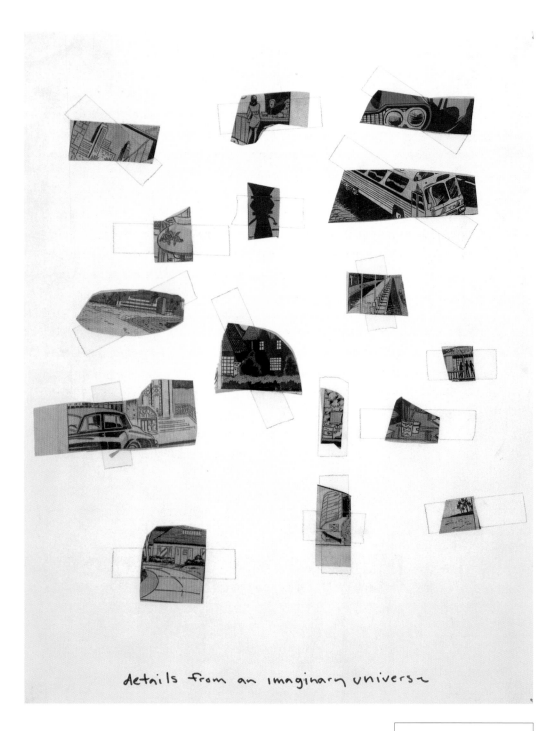

Details from an imaginary universe

ing the journal *internationale situationniste* (1958–69), and the writings published by Guy Debord and Asger Jorn: *Fin de Copenhague* (1957) and *Mémoires* (1959) (figs. p. 32/33, 37).

While the panels in *internationale situationniste*, which often comment on the internal dynamics of the group, attest to the ironic and playful dimension of the »détournement«, it is much more their status as a readily comprehensible visual language that is crucial for the misappropriate use of comic strips as subversive agitprop material. However, through their function as pictorial narratives, which onomatopoetically blend image and language into a single unit, the comic strips also position themselves within the context of the international literary movements of the 1950s. One example is **CONCRETE POETRY**, where language is given a visual form, and **VISUAL POETRY**, where pictorial materials are actually used. Maurice Lemaître (who corresponded with Öyvind Fahlström about these literary ideas, while the latter was still living in Sweden) uses comic strips and other narrative means in his 1950 Lettristic publication *Riff-raff (Canailles)* (fig. 4) in order to tell his own autobiographical war time story.

Hypergraphics is an ensemble of all (pictorial and linguistic) symbols: this is the background of Roberto Altmann who published his *Hypergraphic Chronicle* (fig. 5) in 1967.

The comic strip is used as an internationally comprehensible

MAURICE LEMAÎTRE
Riff-raff (Canailles),
in: UR no. 1
Paris
1950
FIG. 4

ROBERTO ALTMANN
Hypergraphic Chronicle
1967
FIG. 5

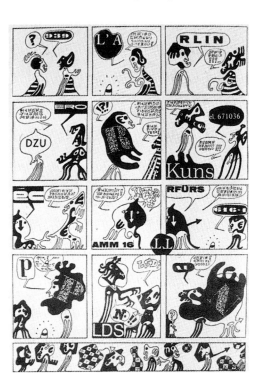

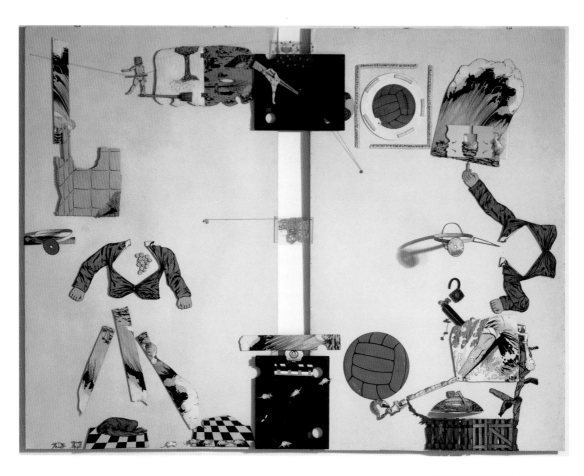

ÖYVIND FAHLSTRÖM
The Cold War
1963–65
Musée national d'art moderne,
Centre Georges Pompidou,
Paris
CAT. 27

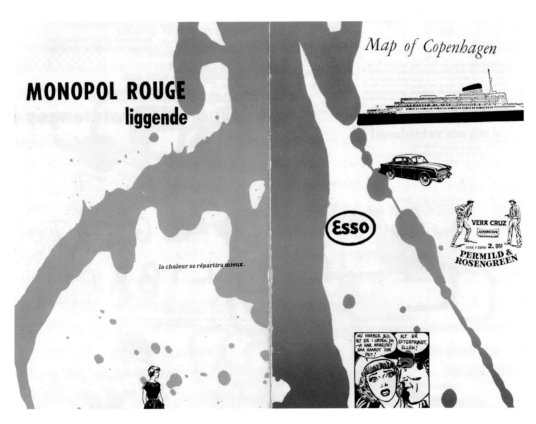

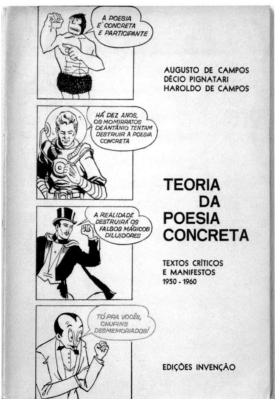

GUY DEBORD UND
ASGER JORN
Fin de Copenhague, 1985
(Reprint from 1957)
Staatgalerie Stuttgart,
Archiv Sohm
CAT. 18

AUGUSTO DE CAMPOS
DÉCIO PIGNATARI,
HAROLDO DE CAMPOS
*Teoria da Poesia
Concreta. Textos Críticos
e Manifestos*
1950–1960
Edições Invenção,
São Paulo 1965
Staatsgalerie Stuttgart,
Archiv Sohm
CAT. 14

pictorial language in the title of an anthology brought out by the Brazilian *Noigandres* Group that is indebted to Concrete Poetry. The title page presents four panels with alienated text balloons, including, for example, the highly popular cave dweller Alley Oop (fig. p. 37).

DIETER ROTH also turned to Concrete Poetry in the 1950s. However, his artists' book *BOK 3 b*, from 1961–66, (fig. above) is to be understood primarily in connection with his method of addressing his cultural environment through its destruction and its subjection to his »omnivorous« artistic potency. *BOK 3 b* (»bok« is Icelandic for book) consists of overlaid pages, cut out at random from comics, with holes punched in them. In this way, books are created whose pages are perceived simultaneously, rendering them illegible, leaving the viewer deeply irritated. Roth's book declares its illegibility primarily through its »ironic gentrification and conservation of the ephemeral [qualities]«[16] of comics and should be seen in the artistic context of his (more radical) processing of books to form »literary sausages«.

DIETER ROTH
BOK 3 b
1961–66
right: detail
Staatsgalerie Stuttgart,
Archiv Sohm
CAT. 70

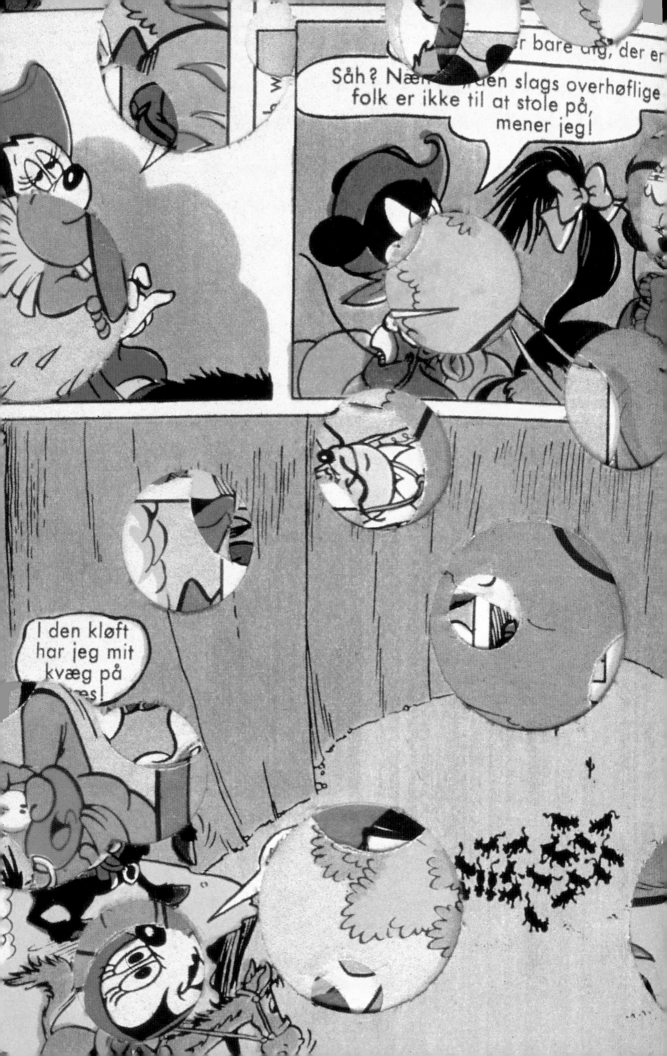

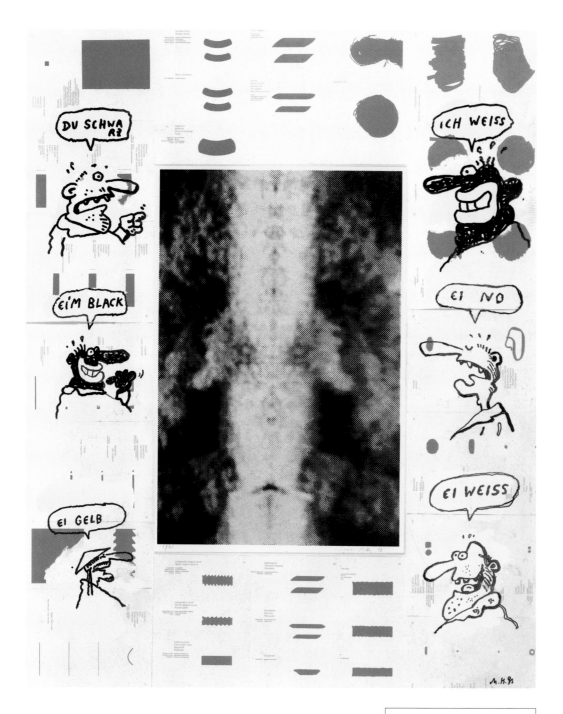

MARTIN KIPPENBERGER
Untitled *(Passepartout für Polke-Graphik)*
1993
Collection Speck, Cologne
CAT. 37

BY CONTRAST, **SIGMAR POLKE** is interested not in the destruction, but in the generation of images, and his oeuvre is consistently shaped by a desire to artistically appropriate mass-media images, in a wealth of different ways. For example, *Lucky Luke and His Friend*, 1971–75, (fig. p.86/87) reveals the typical Polke combination of motifs from widely differing sources, applied using paint as well as spray and stencil techniques. Thus, the different pictorial motifs create a suspense-laden combination, the drama of which is likely to be superior to the parody of the Western film that is set around the laconic figure of Lucky Luke, whose characteristic silhouette is presented here in a clichéd, stereotypical manner. It becomes clear that Polke is not interested in a gentrified stylisation of the original, but rather in an ironic rupture of the visual power of mass-media iconography using manifold artistic manipulations and experimental »disturbances«.

Aesthetic disturbances also characterise **MARTIN KIPPENBERGER'S** immense painterly output; he uses the stock images of everyday life ironically, and breaks down social taboos. This strategy includes making parodic reference to successful fellow artists and making pictorial jokes. In Untitled (*Passepartout für Polke-Graphik*), from 1993, (fig. left), he was inspired by the black-and-white printed matter of the integrated Polke edition to create variations on a politically incorrect joke. He has placed the jokes in the mouths of six figures drawn to resemble the German Werner comic character, in each case punning on the word »Ei« (egg), a recurrent motif in his œuvre. It seems almost natural that Kippenberger, a passionate transgressor of the borders of art and good taste, would choose to reference the Werner character, an anarchic anti-intellectual outlaw who has long since become a cult comic figure in Germany.

MIKE KELLEY — RAYMOND PETTIBON — THADDEUS STRODE

THE WORLD OF COMIC MOTIFS echoes in the form of icons in the oeuvre of Lichtenstein, Warhol and Ramos, and they eschew any inquiry into the narrative content of the comic strips. In contrast, during the 1970s, a fundamentally different artistic approach to these pictorial worlds can be found, especially in the works of Raymond Pettibon and Mike Kelley. On the formal level, the confrontation between »high and low« no longer has any creative potential: Like Polke and Kippenberger, the younger American artists view mass-media images from advertising, film and comics as equivalent motifs of rank for their art. Moreover, Kelley and Pettibon appropriate the formal and structural characteristics of comics particularly for their communicative potential.

Since the 1970s, **MIKE KELLEY** has created black-and-white drawings in an abstract, ab-

»[...] I HAD AN OPPOSITE VIEW OF COMICS THAN MOST
OF THE POP ARTISTS DID. LICHTENSTEIN MIGHT TREAT
THE COMIC AS THIS AMERICANA TYPE OF DERITUS, AND
SEE ART AS A KIND OF ARCHENEMY OF
THE COMIC BOOK. IT THINK THE MEDI-
UM ITSELF IS AS LEGITIMATE AS ANY
OTHER.« RAYMOND PETTIBON[b]

[b] »Raymond Pettibon: Conversation with Dennis Cooper, in: Robert Storr, Dennis Cooper, Ulrich Loock, (ed.), *Raymond Pettibon*, London 2001, p. 11.

breviated shorthand style without, however, ever explicitly resorting to the formal language of comics. Rather, he uses a simplified »illustrative style« to convey complex content – for example, the unconscious, taboo areas and myths of everyday US life – in an easily understandable visual language: »The mode of illustration utilized in comic books is the same as that used in dictionaries or technical manuals. I was not attempting to elevate a ›low‹ form of communication to the status of fine art as with Pop Art; I was simply trying to use a generic mode of illustration and work against its conventional, transparent reading«.[17] In *Missing Time Color Exercise #1*, from 1998, (fig. right) Kelley addresses a real product of US comic culture that had strongly influenced his childhood: the work is a collage in the style of a strict »Modernist« grid using the covers of the *Sex to Sexty* magazines, which, from the mid-1960s, presented sexual innuendos at a fairly banal humorous level in the form of comic strips, caricatures and jokes. The panel shows title pages of a sequence from the early days of the magazine, decorated with the prevalent psychedelic shapes of the 1960s. As Kelley did not have a complete collection of all of the magazines, he positioned monochrome colour panels matching the colours of the missing issues. As Kelley emphasises, his early encounter with what was then frowned upon as the »bible of hick erotica« (Kelley) was an »erotic« experience not only because of the sexual content but also because of the »strange« appealing form of the pictorial stories: »For children, the cartoon image itself has a kind of ›erotic‹ appeal. Part of that appeal probably has to do with the fanciful qualities of the forms and their bright coloration«.[18] With these title pages, Kelley integrated a culture of the »tasteless« quite matter-of-factly into art. At the same time, the piece relates to Kelley's *Missing Time* project where he addresses his own past and memories in a range of different media.

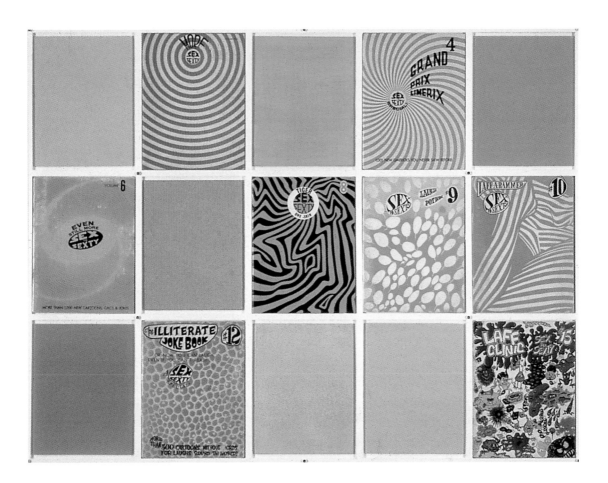

MIKE KELLEY
*Missing Time Color
Exercise #1*
1998
Private collection, courtesy
Jablonka Galerie, Cologne
CAT. 36

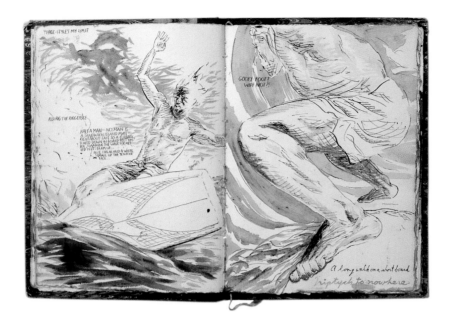

RAYMOND PETTIBON
Paper Nautilus
1992
Detail
Collection Speck, Cologne
CAT. 51

It is important to place Kelley's taboo-breaking discussion of the topic of sexuality (and a child's perception of the subject) into the context of the change in comic culture that has occurred since the late 1960s, when a medium that had originally primarily addressed children was given a new lease of life by the emergence of underground comics with subversive content and artistic innovation. These »comix« (one of their most famous proponents is Robert Crumb) were characterised by topics such as sexism and pornography, drugs, political radicalism and a critique of the establishment; these topics helped to transform the medium into a shocking (distorting) mirror of social reality. For artists like Mike Kelley and Raymond Pettibon, this anarchistic comic culture, as well as music and film, enabled a more adequate reflection on an age shattered by war and social upheaval, an era when the representatives of Pop Art, now an established art form, were considered anachronistic apologists of the outdated »American Myth«.

Sexuality, violence, religion and social subcultures are also the central themes of the multitudinous drawings, booklets and artists' books created by **RAYMOND PETTIBON** (figs. above, p. 46, 101). The medium of the comic is alluded to by the image–text fabric of these works, their narrative content, and their fixed, recurrent repertoire of figures and objects (explosions, airplanes, trains, surfer and the comic figure Gumby etc.). However, Pettibon (who worked as a caricaturist in the 1970s[19]) emphasises the diversity of his pictorial and literary sources and models: film noir, TV, the history of literature from Marcel Proust to Ezra Pound, the painter and poet William Blake, etc. Indeed, in his drawings, the fact that image and text have an equal and contrasting relationship on the semantic level, is the most important difference to the interaction of

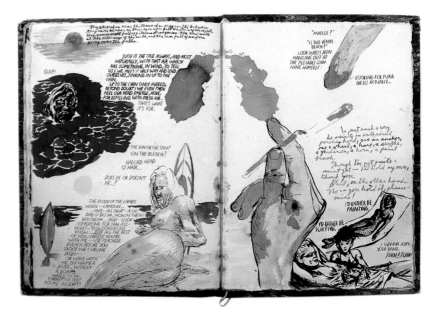

elements in the comic strip (and also to the unequivocal semantic combination of image and text in the work of Roy Lichtenstein). Moreover, Pettibon foregoes any linear narrative structure: the drawings are designed as individual pieces that each contain a fragmentary narrative and challenge the viewer to find his or her own associations and meanings.

The film elements used in the drawings (isolated details, extreme angles) reference Pettibon's notion of the comics as an »extension of film.«[20] In the form of a recurring figure who shouts »Vavoom«, Pettibon presents an actual character from the *Felix the Cat* comic strip, and makes use of the open semantics of the onomatopoetic »primal scream«: »[...] it has multiplicity of meanings which is why I've used that figure and its voice in so many different drawings.«[21]

Like Kelley and Pettibon, **THADDEUS STRODE** can be placed within the context of West Coast Post-Conceptual Art. In his collages and paintings, he interweaves the pictorial worlds of comics and (adventure) films to create fragmentary narratives. By means of decontextualisation and by drawing over snippets from comics, Strode creates »enriched« and individually re-interpreted stories that differ quite fundamentally from the fragmentations of artists like Matt Mullican (figs. p.98/99). In his paintings, Strode makes use of a repertoire of metaphorical figures and objects (shipwrecked boats, stranded figures). The combination of sharp, simplified outlines and monochrome colour fields corresponds to the pictorial language of comics (fig. p.47), but the combination of image and text remains ambiguous and open to association (fig. p.100).

The emergence of **UNDERGROUND COMICS** (»comix«) in the late 1960s in the USA was definitely partly in reaction to the CCA's attempts at censorship. The comics dealt with socially taboo issues such as political radicalism, sexism and racism. Key representatives of this genre are Robert Crumb and Art Spiegelman. Following a period of economic stagnation in the 1970s, the genre was rejuvenated with new content and new forms (e.g., the graphic novel) in the 1980s.

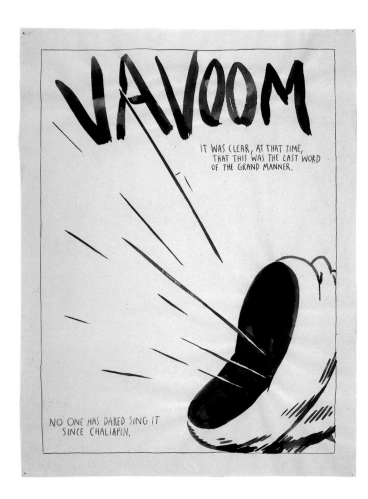

RAYMOND PETTIBON
Vavoom
1988
Collection of the Landesbank
Baden-Württemberg
CAT. 55

*The resulting
consciousness*
1992
Collection of the Landesbank
Baden-Württemberg
CAT. 59

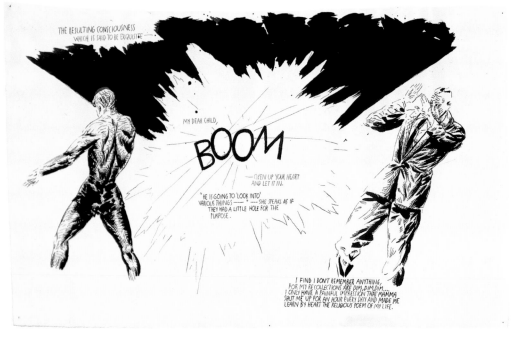

THADDEUS STRODE
Pop Song #2:
Everything Happens,
Follow the Pattern
1997
Collection Falckenberg,
Hamburg
CAT. 89

COMIC STRIPS ARE RADICALLY TRANSFORMED in terms of form and content in the early works of **IDA APPLEBROOG**. The US artist started her career as a sculptor, before creating sequences of drawn images from the 1970s on. The sequentiality of these images lies between comic strips and film strips, their physical form between sculpture and painting.

Not This Time, for example, from 1982, (fig. p.50/51) consists of seven individual cutouts with concurrent motifs in ink and Rhoplex (a bonding agent) on vellum. Within a stage-like space, these images present a woman with a suitcase on a bench, waiting, immersed in her thoughts. The individual images are mounted on a background; their three-dimensional character underscores the impression of a box-shaped peephole theatre. The skin-like nature of the vellum and the colouring impart a kind of corporality to the work. This irritates the viewer, as does the static character of the »story line«, which, in complete contrast to a comic strip or film, is bereft of any dynamism at all. The fragments of sentences written under two of the images – »I'd better not« and »Not this time« – reinforce the temporal duration of the immobile scene. The schematic portrait of the woman, even more exaggerated that the usual cartoon style, renders her a stereotype, while a purportedly everyday setting is shown to contain an element of uncertainty because of the doubts articulated by the woman in an apparent conversation with herself. Irrespective of what the woman is about to do (is she about to leave her husband?), it does not appear to be the »right« thing. In Applebroog's early artists' books,

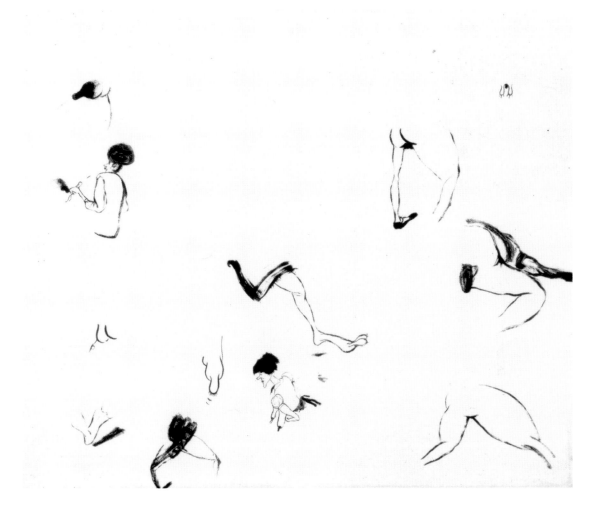

(fig. p.91) the central issue is also the everyday and ostensibly intact relationship between the sexes that is often characterised by dependency or violence. The simplified pictorial language used, reminiscent of comic strips, creates a formulation of this theme that is both restrained and insistent.

In her paintings, **SUE WILLIAMS** addresses the topic of domestic violence and the sexual abuse of women even more explicitly. *Real Fur Hat*, painted in 1995, portrays cartoon-like abstracted fragments of human bodies, distorted extremities and genitalia (fig. above); in *Animal Husbandry* (2002) the graphic line has become grotesquely exaggerated to the point where the shapes dissolve into calligraphy, bringing to mind the Abstract Expressionist paintings of Willem de Kooning (fig. left).

A similarly chaotic entangled web of forms is to be found in the collage *Untitled*, created in 1997/98 by **ARTURO HERRERA** (fig. p.50). Since the early 1990s, however, in his col-

IDA APPLEBROOG
Not This Time
1982
Owned by artist, courtesy
Barbara Gross Galerie,
Munich
CAT. 4

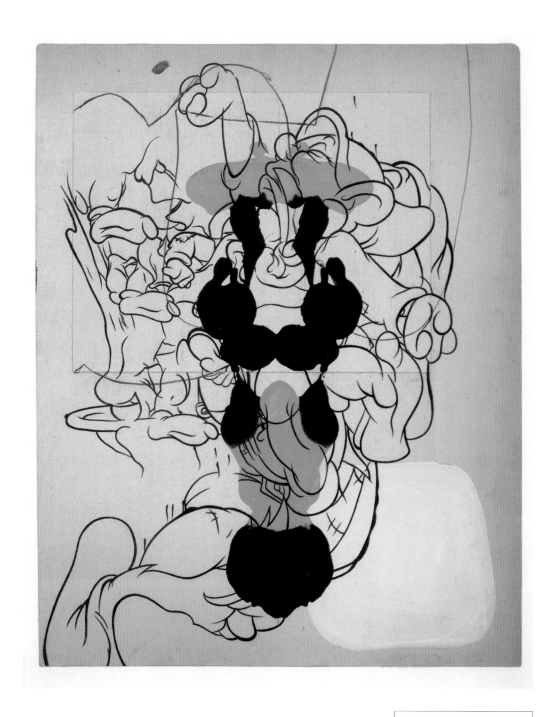

ARTURO HERRERA
Untitled
1997/98
Owned by artist,
courtesy Brent Sikkema,
New York
CAT. 29

lages using fragments from comics and children's colouring books, Herrera has made explicit reference to a world of childlike images whose visual characteristics are buried deep in the cultural consciousness of the West. Herrera instils the dwarves from the Disney animation *Snow White and the Seven Dwarfs* (1937) – epitomes of childish innocence – with an uncanny feeling through his fragmentary, distorting drawing style. This combination of fragmentary metamorphosed bodies contains a surreal element, which is intensified by use of Rorschach shapes – in the characteristic colours of Snow White – in the middle of the piece. To this extent, Herrera's collages play with the ambivalence of the forms, with the transition from the figurative to the abstract and the recognition of »unconscious« images that function as models for the cosmos of motifs encountered in comics.

NEW PICTORIAL WORLDS, INDIVIDUAL NARRATIVES

WILHELM SASNAL – KERRY JAMES MARSHALL

HERRERA WORKS not only with alienation, but also with omission, and as such with the reconstruction of unconscious images. Emptiness and the absence of a subject are also characteristic of **WILHELM SASNAL'S** adaptations of motifs from Art Spiegelman's famous autobiographical comic book *Maus. A Survivor's Tale* (1986). Sasnal, who is Polish, makes use of individual scenes from the Auschwitz concentration camp in his group of work entitled *Maus*, 2001, (figs. p. 84/85). In Spiegelman's book, the father of the first-person narrator, a Polish Jew and Holocaust survivor, describes these scenes. Sasnal's depictions of bunk beds, a prison door and a dark puddle; their extreme reduction to harsh black-and-white contrasts, even more extreme than the characteristic style of shading used by Spiegelman, evoke an insistent and disconcerting mood. Sasnal, who shortly after his graduation in 2001 also created an autobiographical comic strip entitled *Everyday Life in Poland between 1999 and 2001*, praises the »realism« of Spiegelman's comic book and the vivid description of the subjectively felt experience of the war years.[22] At the same time, in Maus he also addresses a virulent social and political problem in Poland – in Spiegelman's book, mice and cats depict Jews and Germans respectively, and pigs embody the Polish population – Sasnal, however portrays a pig as the sole subject of the piece; in doing so, he makes reference to anti-Semitism in Poland, which re-emerged in the 1990s debates on the stance taken by the Polish people during the German occupation.

A clear reference to contemporary society also serves as the basis for *RYTHM MASTR* by

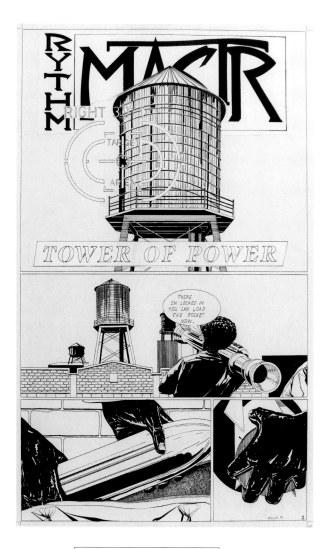

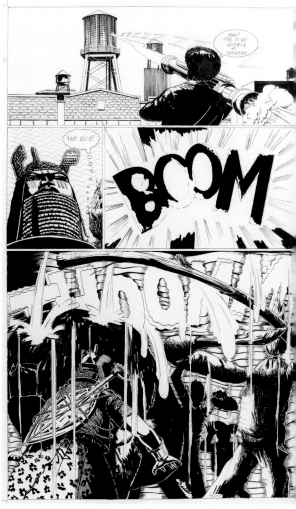

KERRY JAMES MARSHALL
Page layout for
RYTHM MASTR #1–4
1999
Owned by artist, courtesy
Jack Shainman Gallery,
New York
CAT. 42 A–D

»IT WILL NEVER BE POSSIBLE TO DRAW A MORE REALIS-
TIC COMIC STRIP THAN ›MAUS‹. I WAS SURPRISED THAT
ONE CAN DRAG UP EVENTS FROM THE VERY DEPTHS OF
HUMAN EXPERIENCE AND RELATE THEM
IN A COMIC STRIP. THE NARRATION AND
THE COMPLEXITY OF THIS COMIC ARE
AMAZING.«

WILHELM SASNAL[c]

[c] »Wilhelm Sasnal, Interview with Andrzej Przywara«, in: *Wilhelm Sasnal. Night Day Night,* exh. cat. Westfälischer Kunstverein Münster, Kunsthalle Zurich 2003, p.39.

KERRY JAMES MARSHALL (figs. p.54/55). Best known for his large-format paintings, here, in what he views as an ongoing project, Marshall has drawn a comic strip that tells the story of African American superheroes: ethnic minorities were excluded from or under-represented in commercial comics for several decades. When confronted with danger, his heroes rely on futuristic as well as traditional African equipment.

ANGELA BULLOCH – VADIM ZAKHAROV

SINCE THE 1990S, human behaviour and its conditioning have been a central topic of the art of the Canadian **ANGELA BULLOCH**. In From the *S/M Series*, from 1992, (figs. p.58/59) she takes individual motifs from an Italian erotic comic book, removes the actors and some of the scenes and reproduces them as photographic negatives. In the dark rooms, the viewer is left with the whip cracks, screams and groans that emerge from the dark as white representations of onomatopoeia and encourage us to imagine these »forbidden« scenes, as these onomatopoetic utterances generate images when reduced to visual information. The linear narrative of the comics

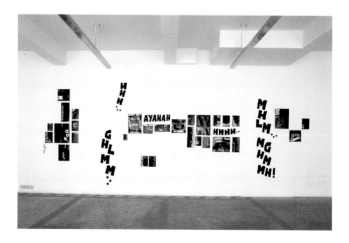

is dissolved; Bulloch then fills the wall with these images. In her first complete presentation of the *S/M Series* in 1992, in addition to the photographs, murals also contributed to create an accessible large installation, which viewers could experience physically and all the more emphatically (fig. 6).

In his *Wörterbuch des nonverbalen Wortschatzes. Mit Kommentaren. Erster Teil: Die Welt der Comicgeräusche* (Dictionary of non-verbal vocabulary. With commentaries. Part one: the world of comic sounds) from 2001, (fig. below) **VADIM ZAKHAROV** offers a wide-ranging glossary of the expressions used to imitate sounds and noises in pictorial narratives and thus render action tangible. In this way, he ironically elevates onomatopoetic utterances, viewed so derisively by cultured users of language, to the level of linguistics, complete with all bibliographical details. A representative of the younger generation of the Moscow Conceptual artists, Zakharov equally explores the functions of language and typography as a creative means for (utopian and, in this case, fictitious) ways of living: However, in the process, he takes the notion of the easy comprehension of onomatopoetic expressions and their general validity as a communal and mutual international language to the point of absurdity.

ANGELA BULLOCH
From the S/M Series
1992
installation view
Esther Schipper,
Cologne 1992
FIG. 6 《《

VADIM ZAKHAROV
Wörterbuch des nonver-
balen Wortschatzes
mit Kommentaren
(Erster Teil: Die Welt
der Comicgeräusche von
Vadim Zakharov und
Daniel Zakharov)
2001
Vadim Zakharov
CAT. 100

ANGELA BULLOCH
From the S/M Series
1992
Collection of the Landes-
bank Baden-Württemberg
CAT. 13

IN THE COSMOS of drawings created by **MARCEL DZAMA** (fig. p. 62/63) we encounter a repertoire of recurrent human, animal and hybrid beings. Using limited coloration and clear lines, these representations are reminiscent of ligne claire comics. However, his »prospect[s] of a strange world«,[23] populated with bear-like and bat-like creatures, among others, reject any incisive narrative conclusion and are, above all, idiosyncratic transformations of the »classic« iconography of comics, shot through with a sense of black humour and surreal exaggeration.

The small-format drawings of **DAVID SHRIGLEY** have the character of a diary. They seem to have been cursorily scribbled down in an amateurish fashion; he often writes (partly erroneous) text in a scrawled hand on paper (figs. below, right, p. 96/97). Shrigley's drawings exhibit a kind of laconic humour that distinguishes them from the explicit punch lines of comics (despite the fact that Shrigley originally wanted to become a car-

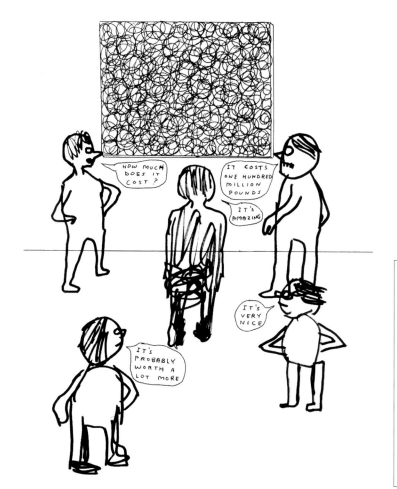

DAVID SHRIGLEY
Untitled *(How much does it cost)*
2003
Courtesy Collection Bruni and Wolfgang Strobel
CAT. 81

Untitled *(Figure looking out of cell)*
2003
Private Collection, Switzerland
CAT. 87 》》

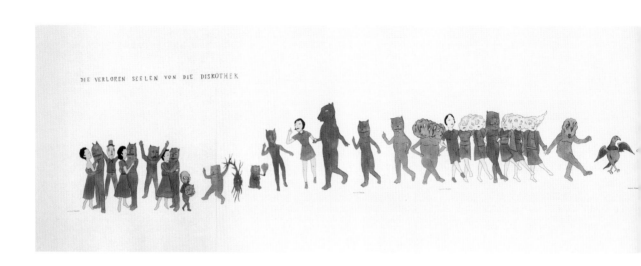

MARCEL DZAMA
*Die verloren Seelen von
die Diskothek*
2004
Private Collection, Dusseldorf,
courtesy Sies + Höke Galerie,
Dusseldorf
CAT. 20

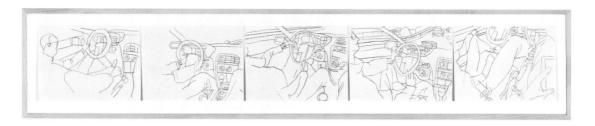

toonist on graduating from art college). Although often published in book form, each drawing is complete in itself and does not venture any further in terms of narrative potential.[24] In an abbreviated, graphic style that always remains on the surface, the drawings illustrate everyday events as well as fantastically surreal, dream-like anecdotes.

Here, failure and death are recurrent motifs – an ironic and fatalistic world view that finds its parallel in the author's ostensible stylistic incompetence.

In her drawings, **DOROTHEA SCHULZ** has developed a specific cartoon-like style in which image and text form an inseparable if incoherent unity (fig. below). This unity is a product of the genesis of the »aural drawings«: the artist transforms what she

DOROTHEA SCHULZ
*victoire, je suis encore
au lit #659, #970*
2004
Owned by artist
CAT. 75

has just heard (voices, sounds) into images. Thus, the sponta-
neous and often erroneous language of the figures drawn us-
ing expressive lines always contains an individual »frozen«
moment of time.

The image sequences, drawn by **ALEXANDER ROOB**, show the
direct depiction of a space–time continuum. Since 1985, his
long-term project *CS* has included numerous drawings that
record everyday movements and workflows in the manner of a reportage. *CS* can mean
»comic strip« and can also be read as the German »sieh es« (see it), a reference to the fo-
cusing of visual perception that Roob also reflects upon in the process of drawing, for
example, through the incorporation of »film« angles as in the 1999 sequence of draw-
ings called *Auto Mainz-Celle* (fig. above). In the early 1980s, Roob worked as an illus-
trator of comics, but he has since endeavoured in his »pictorial novel« project to go be-
yond the form and content of comics; here drawing is given a new lease of life as an in-
strument for the more direct understanding of reality.

ALEXANDER ROOB
Auto Mainz-Celle
1999
Staatsgalerie Stuttgart/
Graphische Sammlung
CAT. 69

JULIAN OPIE

BY VIRTUE OF THEIR SEQUENTIAL NATURE, aims, and objectives (Roob speaks of »lo-
cations« for his sequences of images) and the constant movement of the pencil, which
incessantly records the movements of the body and eyes, Roob's drawings exhibit a dy-
namism that is close to film. The English artist **JULIAN OPIE** has been pursuing a simi-
lar goal for several years. His »portraits« of friends and acquaintances, created in a
range of media, are based on photographs that he reduces digitally to such an extent
that the abstracted image is distinguishable as the portrayal of an individual solely on
the basis of its striking abbreviated outlines. The rigid frontal form of these highly
stylised images dissolves in *Bruce Walking*, from 2004, into a computer-generated ani-
mation of the depicted figure (fig. p. 92). The typical spatial and sequential sequence of
comics is replaced here by the picture-based temporal sequencing of animation, which
in Opie's work, located as it is, between painting and sculpture, plays with the visual
language of advertising and consumer goods.

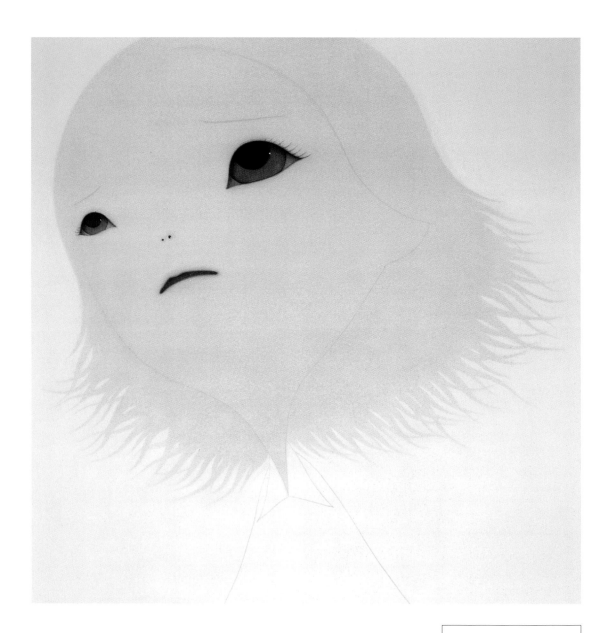

HIDEAKI KAWASHIMA
Please
2003
Private collection, France
CAT. 35

INKA ESSENHIGH'S paintings resemble tales from virtual worlds. In surreal landscapes, amorphous hybrid creatures fight, flee or take a stroll (fig. below). These hybrids, for example, the minotaur in *Arrows of Fear*, 2002, (fig. p.107) or *Mob and the Minotaur*, 2002, (fig. p.94) are only vaguely reminiscent of the iconography of myth. Using powerful expressive lines, Essenhigh augments the movements of these twisting, distorted bodies, seen from an abbreviated perspective, and places them to great effect against the flat colour fields of the background. Like in comics, the »speed lines« of the club in *Mob and the Minotaur* emphasise its violent impact. The potential emotional reaction of the viewer is, however, undermined by the bright flat surface, the decorative style and the

INKA ESSENHIGH
Airport Painting
2003
Collection Goetz, Munich
CAT. 25

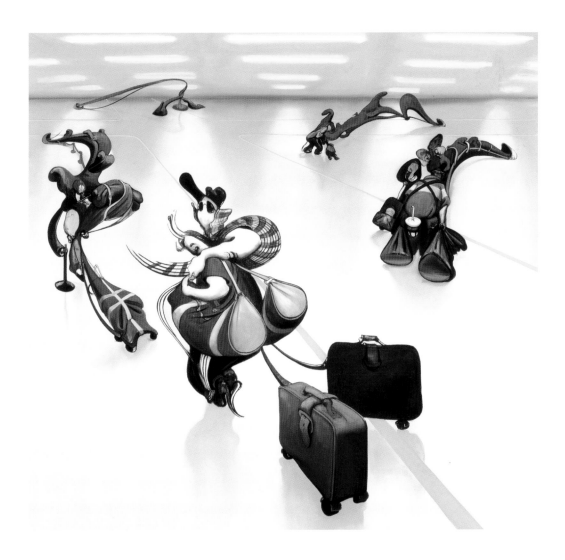

INKA ESSENHIGH[d]

[d] »Inka Essenhigh, Interview with Louisa Buck«, in: *The Art Newspaper*, No. 130, November 2002, p.39

elegant colour matching, revealing the influences of traditional Japanese woodcuts. The expressive dynamism and weightlessness of the cartoon-like figures often create a nightmarishly violent deformation. The metamorphic nature of these hybrid creatures, which appear to distort even more every minute, goes far beyond the transformations of the early, anthropomorphic Disney characters, and refers to the visual experience of the Japanese comic culture of manga and anime, whose narrative worlds and characters also undergo permanent change.

HIDEAKI KAWASHIMA — YOSHITOMO NARA — YOSHITAKA AMANO — TAKASHI MURAKAMI — TIM EITEL

From the very beginning of its mass distribution during the American occupation following World War II, the manga, which developed out of the »floating, transitory world« of the traditional Japanese coloured woodcut, has been characterised by greater diversity of form and content than are Western comics. In Japan, it has developed into an entertainment medium of equal status to TV or film that is aimed at a broad range of different social groups, using liberal pictorial narratives that are less restricted by social taboos. Indeed, in recent years we have seen adaptations of the manga in the form of anime films and the comprehensive marketing strategies used to promote manga characters have a substantial influence on visual culture, an influence that is reflected in diverse ways in contemporary Japanese art.[25]

The delicate figures drawn in tender pastel tones in the paintings of **HIDEAKI KAWASHIMA** (fig. p.66), are one example; they exude a vulnerability and innocence which echoes the cult of childhood associated with the success of the manga. The sudden rupture between an extremely sheltered childhood and the high requirements of a competitive society is a

INKA ESSENHIGH
Arrows of Fear
Detail
2002
Collection Goetz, Munich
CAT. 24

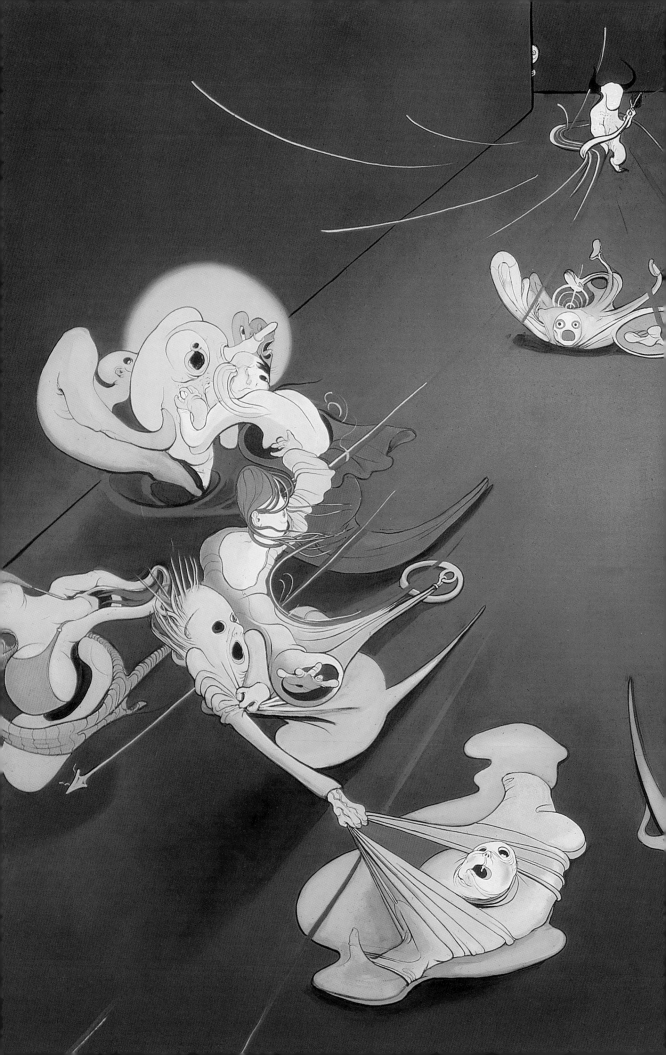

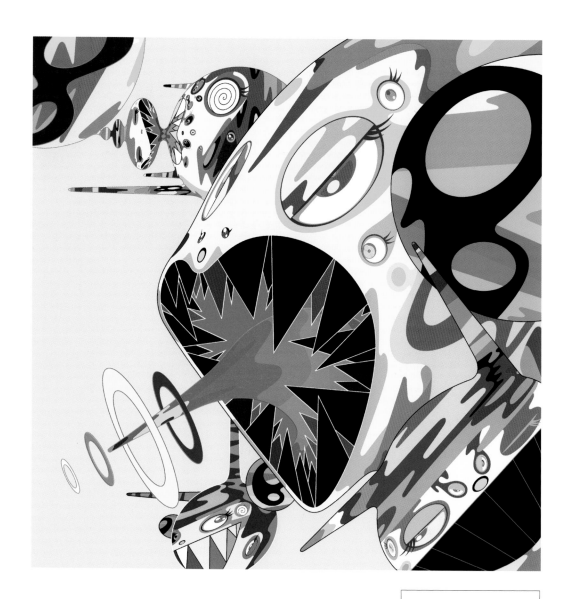

TAKASHI MURAKAMI
*Homage to Francis
Bacon (Study of Isabel
Rawsthorne)*
2002
Courtesy Galerie Emmanuel
Perrotin, Paris
© 2002 Takashi Murakami/
Kaikai Kiki Co., Ltd. All rights
reserved.
CAT. 44

traumatic experience for many Japanese people. In this respect, the »easily digestible« pictorial narratives of the manga and anime offer welcome opportunities for flight into fantasy worlds and so, ultimately, fulfil a social and compensatory function.[26]

The view of childhood as a psychologically and socially complex topic also predominates in the works of **YOSHITOMO NARA**. His drawings and sculptures portray stylised figures of children with oversized heads and eyes, who at first sight appear harmless and sweet, alluding to kawaii, the ideal of cuteness that is the aesthetic characteristic of many mangas (figs. p. 116–118). Equally, these child figures frequently appear not only lonely and lost, but sometimes have screwed-up eyes and are even armed, and appear aggressive. Both vulnerable and evil, they confront the viewer and thus the world of adults, an unpredictable social factor that refuses to be innocent and conformist, and stands the ideal of childlike kawaii on its head. Nara pays homage to this non-conformism in his drawings, which propose a child's perspective of the world because of their stylistic links to cartoon figures and illustrations in children's books. In this exhibition, they are displayed in a specially created pavilion that offers a concentrated version of the artist's poetic and subjective view of the world.

MANGA, are Japanese comics and emerged in their present form after World War II. The most influential trailblazer was Osamu Tezuka (*Astro Boy*, 1951). The term (MAN: spontaneous, aimless; GA: picture, drawing) dates back to the woodcuts made by Hokusai (1760–1849). Mangas are characterised by the priority given to the drawings over the texts, the flat images and the narrative technique of film, as well as the »cute« characterisation of the figures (»kawaii«). An immense manga industry exists in Japan covering a broad range of content and appealing to just about every target group, from infants to senior citizens. The influence of the medium on everyday life in Japanese society cannot be overestimated.

Like Yoshitomo Nara, who in addition to his drawings also illustrates books, CD covers and brought out a series of wristwatches, **YOSHITAKA AMANO** also moves easily between the fine and applied arts. He has made a name for himself as a character designer for animated films and video games. The suggestive pictorial language of his (commercial) figures is transposed into his stylised drawings of futuristic comic characters; in his ink drawings and lacquer paintings, (figs. p. 95, 108, 125) on the other hand, he uses traditional Japanese art forms.

In contrast, the artistic form that **TAKASHI MURAKAMI** gives to the world around him appears to have definite aims and objectives. For his *Hiropon Factory*, created in the image of Andy Warhol's Factory, he developed an extensive range of products (toys, textiles, wallpaper, and most recently, in cooperation with Louis Vuitton, bags). As such, he is truly an exemplary model of the artistic style that has appropriated manga and anime images and brilliantly transformed them, before it went forth and conquered Western markets. This is also something that **TIM EITEL** seems to laconically state in his museum pictures (figs. p. 77, 127).

Murakami's contribution to current production and reception of Japanese art is not

As regards content, the Japanese animated cartoons ANIME (from the French *animé* or animated) have a similar content to manga, ranging from child-friendly adventure stories to film versions of books through to horror and science fiction themes. Anime are often based on successful mangas (e.g., *Akira, Ghost in the Shell*). The two most successful movies in Japan to date – Hayao Miyazaki's anime *Princess Mononoke* (1997) and *Spirited Away* (2002) – were also extremely successful in the West.

only the result of his role as artist-curator who surrounds himself with a group of *Factory* members but also of the theoretical foundation – given the name of »superflat« – that is the basis of his blend of artistic and commercial strategies. According to Murakami, the flat nature of traditional Japanese art and of Western art since Andy Warhol – and by extension, contemporary art – corresponds to the way children and young adults, who have grown up with the »flat« images of the computer screen, view art.[27] Murakami's smooth polished surfaces, descendants of traditional Japanese Nihonga painting, are »flat« representations devoid of content that indeed do justice to these new viewing habits. With his repertoire of stylised and grotesquely distorted figures, Murakami also undermines the kawaii ideal of the manga, as his figures do not possess any »signifying« properties at all. As such, they are the direct opposite of figures from comics and mangas, who are always characterised by certain specific features (fig. right). His deformed and ostensibly transformative beings in *Homage to Francis Bacon (Study of Isabel Rawsthorne)* (fig. p.70), from 2002, show to what extent truly unique and new images can arise from the confrontation with the »intrinsic« pictorial worlds of mangas and animes and an engagement with European art history.

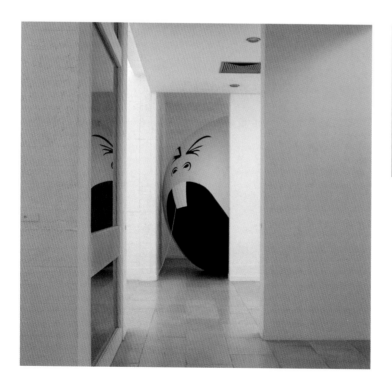

PHILIPPE PARRENO
No More Reality,
Batman Returns
1993
installation view Villa Arson,
Nice, 1993
Private collection, Courtesy
Esther Schipper
CAT. 49

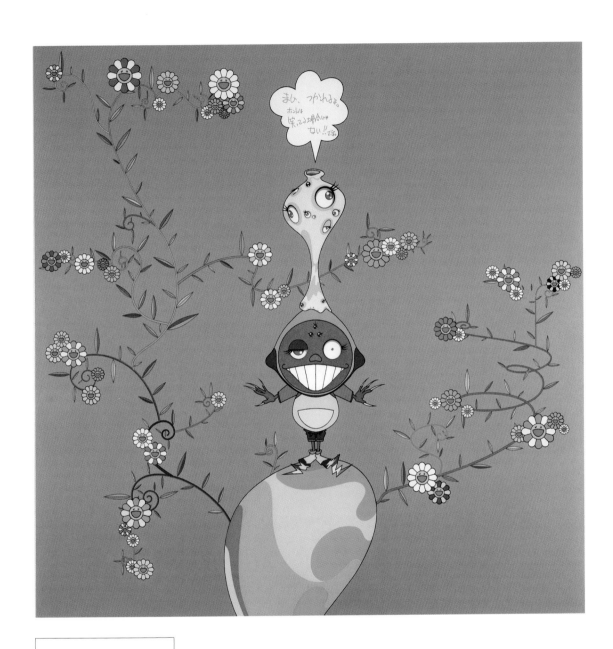

PHILIPPE PARRENO
No Ghost Just a Shell:
Anywhere Out of the World
2000
Musée d'Art Moderne de
la Ville de Paris
CAT. 50

THE JOINT PROJECT of **PIERRE HUYGHE** and **PHILIPPE PARRENO** entitled *No Ghost Just a Shell* (1999–2002) takes the virtual world of the manga and anime as its point of departure (figs. left and below). In 1999, the artists acquired the copyright and the original image (the master files) of the AnnLee character created by a Japanese design agency. Her simple »personality structure«, meant that this bargain-basement character was only destined to play a very brief role in the narrative development of a manga series and so she was »disposed of« by the agency; the artists essentially saved her from being forgotten. A further thirteen artists were asked to participate in this technically

PIERRE HUYGHE
No Ghost Just a Shell: Two Minutes out of Time
2000
Courtesy Galerie Marian Goodman, Paris
CAT. 34

complex, long-term project; AnnLee's appearance and characteristics were changed in the course of different individual video episodes. She was given a range of new identities: lonely child-like heroines that nevertheless always bore a certain resemblance to the figures of children drawn by Yoshitomo Nara. Although Huyghe and Parreno also address issues such as authorship and the relationship between autonomous artistic practice and the conditions of commercial production in *No Ghost Just a Shell*, the project primarily relates to the new opportunities for visual narrative afforded by the new worlds of manga and anime images.

THE EXTRAORDINARY DIVERSITY, not just of the most recent works in this exhibition, makes quite clear that the discussion of the use of cartoon and comic images in contemporary art has regained its topicality. In terms of content and form, the approach of artists today differs fundamentally from the early works featured in this exhibition. British and US Pop Art viewed comics as everyday icons »unworthy of art«, and the direct references and the iconic nature of their motifs say a great deal about the fascination and the »outrageousness« of this confrontation with »high« art. The very personal approach of Blake, Ramos, and Warhol is replaced, for example, in the works of Erró and Fahlström, by an examination of the function of the pictorial language of comics. These trivial pictorial worlds are understood as a means of inserting subversive, critical content into art; although artists like Fahlström and Baruchello abandon any fixation on the existing comic motif, and adopt fragmentation as a method of generating images, the narrative potential of the image–text stories now moves to the foreground.

In contemporary art, the dissolution and appropriation of existing comic iconographies results in many different approaches. In their works, Sue Williams and Arturo Herrera explore the dividing line between figuration and abstraction. The work of Inka Essenhigh and Takashi Murakami follow this approach to the point where the »intact« body dissolves, reflecting the experience of virtual imagery in anime films. The focus on social conditions today and the connection to real life in the work of Williams, Applebroog, Marshall, and Sasnal forms an antipole to the »escapist« creation of new identities, influenced by the anime, in the virtual spaces of video art (Parreno, Huyghe). It is not least the diversity of artistic approaches that demonstrates that the humorous, anarchic and often radical examples of the easily accessible, floating worlds of images in comics and cartoons, mangas and animes have lost none of their fascination.

TIM EITEL
Murakami
2001
Art Collection of the
Sachsen LB
CAT. 22

1 »Öyvind Fahlström, The Comics as an Art (1954)«, in: *Öyvind Fahlström: Another Space for Painting*, exh. cat., Museu d'Art Contemporani de Barcelona, Barcelona 2000/2001, pp.114/5.

2 For more on the affinities between the surreal images of *Krazy Kat* and the work of Joan Miró see: Kirk Varnedoe and Adam Gopnik (eds.), *High & Low: modern art, popular culture*, New York, 1990, pp. 153–228. The topic is considered from the vantage point of media and art history in Sheena Wagstaff (ed.), *Comic Iconoclasm*, exh. cat., Institute of Contemporary Arts, London, 1987 et al., and John Carlin and Sheena Wagstaff (eds.), *The Comic Art Show. Cartoons in Painting and Popular Culture*, exh. cat., Whitney Museum of American Art, New York, 1983. For a contemporary US focus see: Vicky A. Clark et al. (eds.), *Comic Release. Negotiating Identity for a New Generation*, exh. cat., Carnegie Mellon University, Pittsburgh, 2003, et al. and Valerie Cassel (ed.), *Splat Boom Pow! The Influence of Cartoons in Contemporary Art*, exh. cat, Contemporary Arts Museum Houston, 2003, et al. A smaller show concentrating on the influence of comics and computer games on contemporary painting took place in 1999/2000 at the Württembergischer Kunstverein Stuttgart: Ralf Christofori (ed.), *Color Me Blind! Malerei in Zeiten von Computergame und Comic*, Cologne, 1999.

3 »Richard Hamilton: comments on his work (1961 and 1956)«, in: *Richard Hamilton*, exh. cat., New York, et al. 1974, no pagination.

4 Ramos' works were created in the early 1960s – the second era of the superheroes in comics – when characters from the 1940s were given a new lease of life, partly in new guises (»The Flash«) and new figures such as Daredevil and The Incredible Hulk were added to the genre. The multimedia utilisation in radio and TV broadcasts, comic strips and books increased the popularity of the early superheroes, for example the pilot Captain Midnight, (based on a real-life person) and Batman, who first appeared in 1939, and progressed to cult status thanks to a Pop Art influenced TV series that began in 1966.

5 See also Mel Ramos, in: Elizabeth Claridge, *Mel Ramos*, Darmstadt 1975, p.26.

6 See also Benjamin H.D. Buchloh, »An Interview with Andy Warhol«, in: Annette Michelson (ed.), *Andy Warhol, October Files* 2, Cambridge, London 2001, p.120.

7 See Michael Moon, »Screen Memories, or, Pop Comes from the Outside: Warhol and Queer Childhood«, in: Jennifer Doyle, Jonathan Flatley, and José Esteban Muñoz (ed.), *Pop Out. Queer Warhol*, Durham (North Carolina), London 1996, pp.78–100.

8 At the end of the 1950s, Lichtenstein had already created pictures of Donald Duck, Mickey Mouse and other comic figures. After a brief abstract phase, he moved on to his abstract comic adaptations.

9 See also Roger Sabin, »Quote and Be Damned …?«, in: *Splat Boom Pow! The Influence of Cartoons in Contemporary Art* (see note 2), p.11.

10 See also Roger Sabin, *Comics, Comix & Graphic Novels. A History of Comic Art*, London 2002, p.35.

11 »Hervé Télémaque, Interview with Jacques Gourgue«, in: *Télémaque*, exh. cat., IVAM Centre Julio González, Valencia 1998, p.156.

12 *Bande dessinée et figuration narrative*, exhibition in the Musée des arts décoratifs, Palais du Louvre, Paris 1967.

13 Öyvind Fahlström, »Manifesto for concrete poetry (1953)«, in: *Öyvind Fahlström: Another Space for Painting*, exh. cat., Museu d'Art Contemporani de Barcelona, Barcelona 2000/2001, p.59.

14 Matt Mullican, in: *Global World – Private Universe*, exh. cat., Städtische Galerie im Lenbachhaus, Munich, Munich 1999, no pagination.

15 Libero Andreotti: »›Stadtluft macht frei‹ (Max Weber). Die urbane Politik der Situationistischen Internationale«, in: *Situationistische Internationale 1957–1972*, exh. cat., Museum Moderner Kunst Stiftung Ludwig Vienna, Vienna 1998, p.23.

16 Ina Conzen, »Bücher und Buchobjekte«, in: *Dieter Roth. Die Haut der Welt*, Sohm Dossier 2, Staatsgalerie Stuttgart 2000, p.56.

17 »Mike Kelley, Conversation with Isabelle Graw«, in: John C. Welchman, Isabelle Graw and Anthony Vidler (eds.), *Mike Kelley*, London 1999, p.15.

18 »Black Nostalgie. An Interview with Mike Kelley by Daniel Kothenschulte«, in: *Mike Kelley,* exh. cat., Kunstverein Braunschweig 1999, Köln 1999, p.52.

19 In the 1980s, Pettibon made a contribution to Crumb's *Weirdo* anthology.

20 »Raymond Pettibon: Conversation with Dennis Cooper«, in: Robert Storr, Dennis Cooper and Ulrich Loock (eds.), *Raymond Pettibon*, London, 2001, p.11. Film montage, changing camera angles and an effective style of shading were typical of the comic strips – influenced by film noir – drawn by Alex Raymond in the 1940s.

21 Raymond Pettibon, »In conversation with Ulrich Loock«, in: *Raymond Pettibon,* exh. cat., Kunsthalle Bern, 1995, p.28.

22 See also »Wilhelm Sasnal: Interview with Andrzej Przywara«, in: *Wilhelm Sasnal. Night Day Night*, exh. cat., Westfälischer Kunstverein Münster, Kunsthalle Zurich 2003, p.39.

23 Catrin Lorch, »Marcel Dzama«, in: *Marcel Dzama. Paintings and drawings*, exh. cat., Galerie Sies + Höke, Dusseldorf 2004, no pagination

24 Recently, Shrigley has created online animations; see *http://www.mudam.lu/shrigley and http://www.zenomap.org/artists/shrigley/index.html* (14.08.04.)

25 See also Margrit Brehm (ed.), *The Japanese Experience – Inevitable*, exh. cat., Ursula Blickle Stiftung, Kraichtal, 2002, Ostfildern-Ruit, 2002, and *My Reality. Contemporary Art and the Culture of Japanese Animation*, exh. cat., Des Moines Center and Independent Curators International, New York et al., 2001–2004, Des Moines, 2001. The latter exhibition focused on international art and the influence of video game culture.

26 See also Jaqueline Berndt, *Phänomen Manga: Comic-Kultur in Japan*, Berlin 1995.

27 See also Takashi Murakami, *Superflat*, Tokyo 2000.

PHOTO CREDITS

fig.2: Anonymous, Original template for Roy Lichtenstein: *Takka Takka*, 1962, in: Diane Waldman, *Roy Lichtenstein, Die Retrospektive*, Haus der Kunst, Munich, 1994/1995, p.95, fig.83.

fig.4: in: Roberto Ohrt, *Phantom Avantgarde. Eine Geschichte der Situationistischen Internationale und der modernen Kunst*, Hamburg 1990, p.29.

fig.5: in: Stephen C. Foster, *Lettrism: Into the Present*, The University of Iowa Museum of Art, Iowa 1983, p.37.

fig.6: Photo ©: Lothar Schnepf, courtesy of Esther Schipper, Berlin.

SUPER BIG SISTER

THE LINE IN PAINTING AFTER

COMICS

ANDREAS SCHALHORN

MAN'S

EACH ACT MUST HAVE CONSEQUENCE

EACH LINE DOES HAVE MEANING

LAWRENCE WEINER[1]

AS THE VIEWER SURVEYS THE EXHIBITS of *Funny Cuts*, he or she will see that important role the line plays in the visualisation of comic-like figurations and episodes. This particular significance refers, on the one hand, to »classical« drawings on paper. It may not seem particularly original to state that the line is present in drawings – since, by its very nature, drawing is the medium of the line. As the works of DAVID SHRIGLEY, YOSHITOMO NARA, MARCEL DZAMA, DOROTHEA SCHULZ and RAYMOND PETTIBON demonstrate, contemporary drawing that takes its cue from comics is characterised by a great diversity of pictorial languages, which are articulated in many different linear and figurative styles.

The following comments, which address formal aspects, focus on an issue that is easily overlooked: since the 1960s, the line, in a range of variations on the comic style, has also influenced painting. As this essay will show, the status of the line as an artistic means of representation is an ambivalent one.

The dominance of the line as the basis of comic-style influenced painting and graphic art is inextricably linked to the comics that are referred to or paraphrased: and so to a key characteristic of comic strips, cartoons and animated cartoons (cf., *The Simpsons*): irrespective of whether the publications in question are American, European or Japanese, in the majority of cases, the treatment of the figures and the framed panels of a pictorial sequence is based on the line drawing. Word bubbles and abbreviations repre-

senting the emotional and physical states of the individual characters are also developed accordingly.[2] The mass reproduction of the finished drawings, made possible through offset printing, further transposes the linearity of the comic.

ERRÓS *Comicscape,* (fig. p.110/111) a pantheon of comic heroes, highlights the typical outline style used in conventional comic strips. The homogeneous colouring of the outlined surfaces and spatial zones, a product of basic multicolour printing, can accompany the customary black printed line. This »flat« colouring – Hergé's *Tintin* comics are the classic example – generates, in combination with the silhouette-like nature created by the outline, the easy and quick comprehension of the comic images.

The primarily linear character of the comic strip, which does not necessarily require the definition of colour (see *Peanuts* by Charles M. Schulz), prompted ROY LICHTENSTEIN in 1961 to create *Knock, Knock.*[3] This drawing was later reproduced as an offset lithograph on hand-made paper in 1975 (see fig. 1).[4]

In *Knock Knock*, Lichtenstein augments the scene from a comic, that he may even have further distilled, and thus makes its simple and yet effective structure very clear: it is solely through the combination of simple black lines that he develops a door and pointers towards the action continued in the next scene – the schematic representation of »knock, knock.« In the painting, *Takka Takka*, 1962, (fig. p.21) there

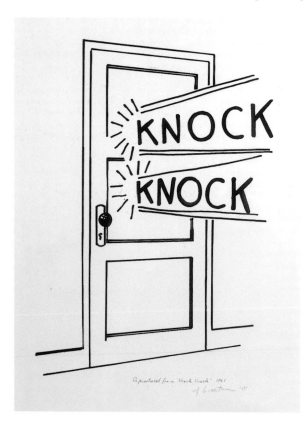

ROY LICHTENSTEIN
Knock, Knock
1975
Staatliche Museen zu Berlin,
Kupferstichkabinett,
Collection Hans + Uschi Welle
FIG. 1

Pow! Sweet Dreams,
Baby!
1965
Staatsgalerie Stuttgart/
Graphische Sammlung
CAT. 41

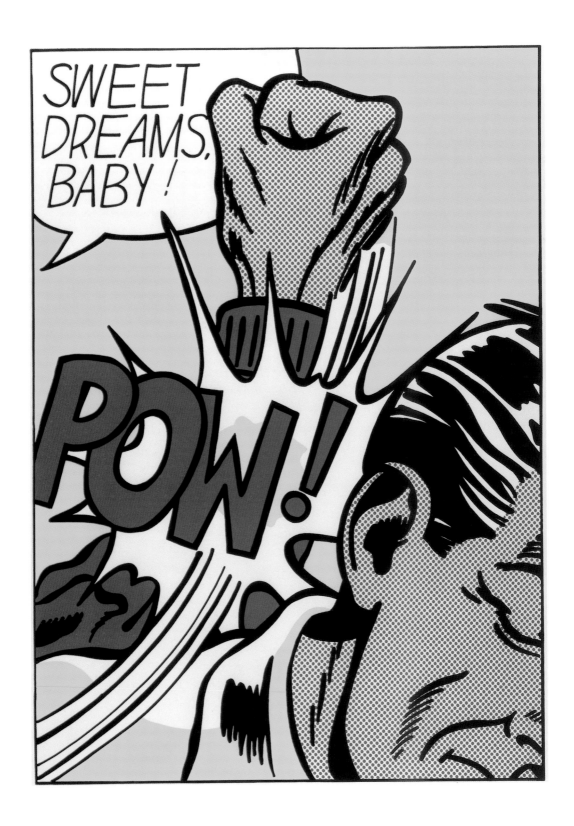

is a framework of black lines that, in keeping with the printed comic originals, has also been filled with colour. In his painting, Lichtenstein analyses the linear and colour schematisation that accompanies the reproduction of images in the medium of print, and, equally, the mechanisms that take place during the duplication of original images in a multi-stage printing process. This results in simplifications, even abstractions, that can, however, only be perceived from close-up, and not, in the normal course of things, by the readers of comics.

While formal abstraction in a printed comic serves »to reduce things to the essential in the course of an economic use of pictorial devices as well as to simplify things with re-gard to heightening the recognition value of the scenes and figures,«[5] In this way, Licht-enstein, intensifies the process of abstraction; for example, he treats colour as »a quan-tifiable variable, as if it were printer's ink. An illustrator of comics never colours in the sketched outlines him- or herself; it is enough to define the respective colour tone and density: the coloured comic image emerges for the first time during the printing process. Lichtenstein simulates this process by hand ...«.[6] The line drawn or painted by Lichten-stein, however, actually imitates the anonymous line produced and duplicated in the printing process. Unlike the graphic works of younger artists like David Shrigley or Marcel Dzama, (fig. p.62/63) the line as painted by Lichtenstein (even as parallel-hatching) is never drawn directly or spontaneously: rather, it is the imitation and alien-

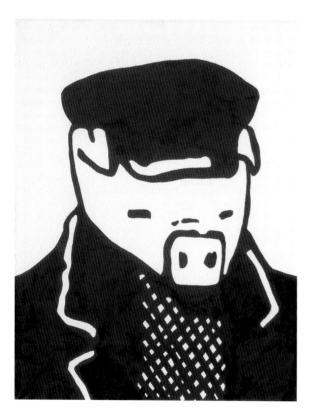

WILHELM SASNAL
Maus, 2001
Owned by artist
CAT. 73

Maus, 2001
Owned by artist
CAT. 71

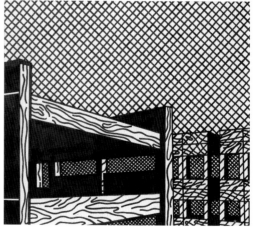

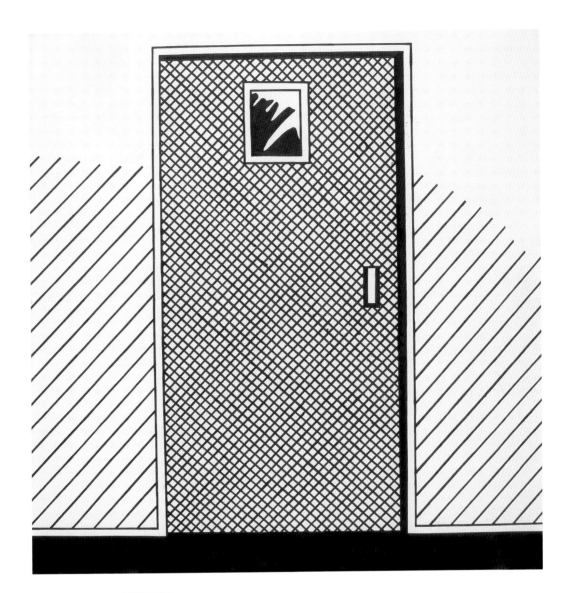

WILHELM SASNAL
Maus
2001
Owned by artist
CAT. 72

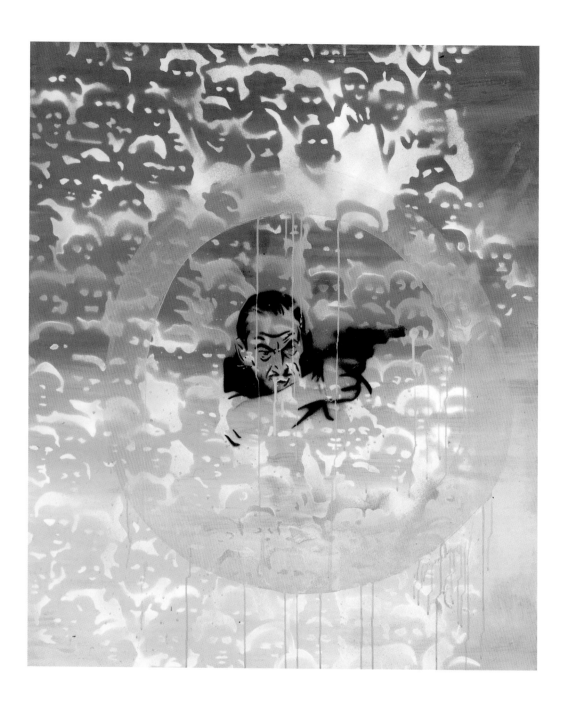

SIGMAR POLKE
*Lucky Luke and His
Friend*
1971–75
2 parts
Collection Lergon
CAT. 65

ation of a reprographic technique. In consequence, his pictures reveal themselves, through the processes of abstraction of the figurative subject based in the reprographic process, as the results of artistic abstraction. Media reflection coincides with media transfer.

As the background of the *Takka Takka* makes clear, one of the elements that Lichtenstein treated with special interest in his work (and for which he would soon use stencils), were Benday dots, used in newspapers to generate half-tones: »The Benday dots were what Andy Warhol so enviously admired in Lichtenstein's comic paintings. More than even the black outlining of the figures and the limited range of industrial colours, it was the Benday dots that seemed to be most out of place in a painting.«[7] On the oth-

er hand, Lichtenstein's depiction of the printed line displays one significant difference to the strategy of Andy Warhol: the latter did not merely imitate the reprographic method of silk-screen printing; instead he used it to create his works on canvas and paper. He only focused on the phenomenon of the printed outline in his early work and in the 1980s.[8]

ROY LICHTENSTEIN
Crying Girl
1963
Staatsgalerie Stuttgart/
Graphische Sammlung
CAT. 39

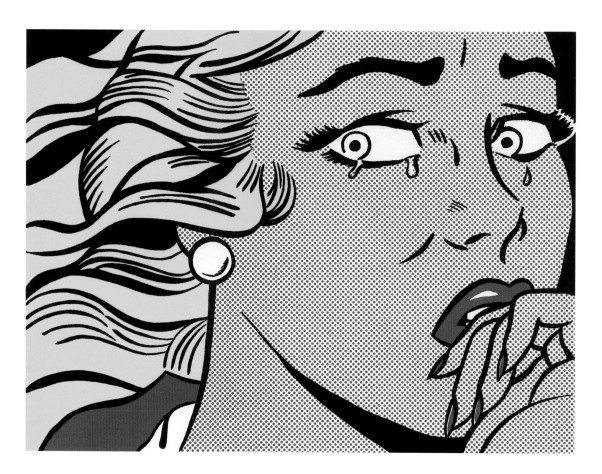

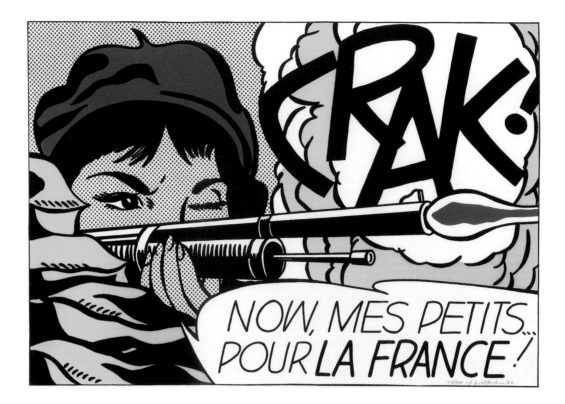

ROY LICHTENSTEIN
Crak!
1964
Staatsgalerie Stuttgart/
Graphische Sammlung
CAT. 40

The linear simplification of the printed comic is found again, with a quite a different emphasis as regards content, in contemporary art; for example, in the works of WILHELM SASNAL, who enlarges black-and-white details from Art Spiegelman's comic *Maus* in his paintings. The graphic texture is therefore intensified, as in the severe latticework of a cross-hatched wall (figs. p.84/85), and this intensification exposes and emphasises, particularly in the scenes without figures, the psychologically and physically oppressive reality of the concentration camp that Spiegelman's comic addresses. Equally, the absence of any narrative gives rise to a strange tension and uncertainty in the viewer. The door in Lichtenstein's *Knock, Knock* is indeed carefree in comparison.

While in Sasnal's pictures, the framework of lines has implications for the content that go beyond formal reference to the black printed lines of comics, in *Lucky Luke and His Friend*, (fig. p.86/87) SIGMAR POLKE takes a playful and ironic look at different forms of stylistic representation of figures. The diptych contains a figure in outline, while the other protagonists, (including Lucky Luke himself) are created using grids and stencils. Here, Polke employs the pochoir, a stencilled graffito that has been mainly utilised with a political agenda, particularly in France, since the 1970s.[9] The poichor is applied swiftly (and usually illegally) to walls by means of a prepared cardboard stencil and

spray paint. Polke, however, takes the silhouette of Lucky Luke that is transposed onto the screen (Lucky Luke is just about to take out his pistol; his »friend« would seem to be quicker on the draw) and combines it with calculated exaggeration with a dot screen.

THE LINE IN PAINTING SINCE THE 1960S

DURING THE DEVELOPMENT of modern painting, the line as an integral part of the picture (like colour) gradually distanced itself from the function of designating objects. While the line held a dominant position in various different formulations (e.g., the surreal and expressive: Joan Miró, Arshile Gorky; the abstract and expressive: Hans Hartung) in post-war non-figurative painting as an autonomous pictorial sign, it attained a new function in figurative Pop Art paintings as a figure-based and figure-defining element. In the 1980s, in a kind of backlash against the »rejection of images« of the Concept Art of the 1970s, a renewed interest in figurative painting also led to a new use of the line. KEITH HARING was without doubt the most important proponent of strongly expressive line painting; he cultivated his own unique, striking graffiti style and transposed it into the world of galleries. He adapted comic figures like Mickey Mouse only in a few cases. In his wide-ranging oeuvre, Haring created his own world of figures, which he developed from a painted and often coloured line. Logo-like figures such as his famous »Radiant Baby« contrast with the complex, often ornamental networks of lines that highlight

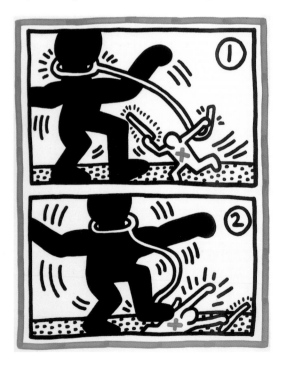

his masterful ability to fill pictorial space using the painted line. Haring is the 1980s Pop artist who best understood how to disseminate his motifs and topics through the mass production of articles (t-shirts, mugs), which were decorated with prints of his line figures. His dichromic political lithograph *Untitled (Free Africa)*, from 1985, (see fig. 2) is not

KEITH HARING
Untitled *(Free Africa)*
1985
Staatliche Museen zu Berlin,
Kupferstichkabinett,
Collection Hans + Uschi Welle
© Estate of Keith Haring
FIG. 2

IDA APPLEBROOG
*The Sweet Smell of Sage.
A Performance*
1979
Staatsgalerie Stuttgart,
Archiv Sohm
CAT. 8

*I feel Sorry for you.
A Performance*
1979
Staatsgalerie Stuttgart,
Archiv Sohm
CAT. 9

only a perfect example of the way he created a figure using an outline or silhouette.[10] This work is intuitive in the true sense of word, as in a cartoon or comic strip, he also works with panels: the two scenes are to be construed as a sequence.

Since the 1970s, sequences of simple panels are also to be encountered in the work of IDA APPLEBROOG (figs. p.50/51, above). During this time, she has combined the predominant graphic element with painted sections. Her frequent use of vellum instils a special sense of fragility into the drawings and paintings, whose muted or earthen tones have nothing in common with the Pop world of Haring. Moreover, the vellum brings to mind the vulnerability and sensuousness of skin: an aspect that is not irrelevant to Applebroog's subtle and nightmarish analysis of communication and the latent power structure between men and women.

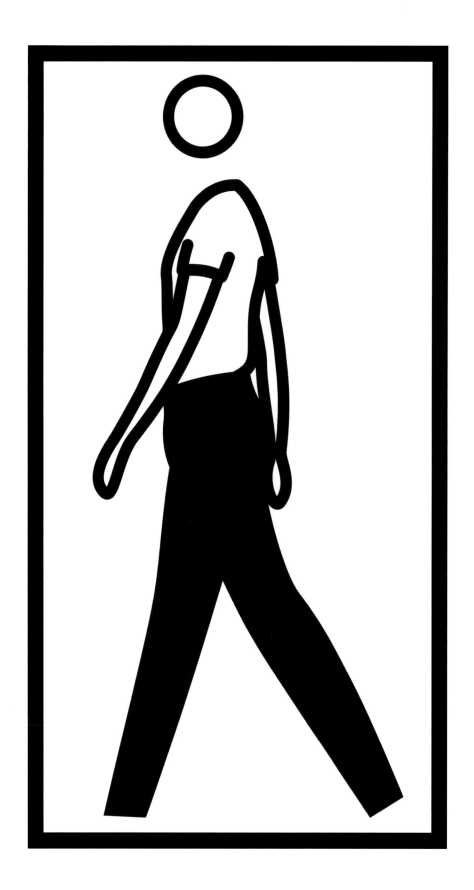

SUPERMAN'S BIG SISTER

THE CONSIDERATION of Roy Lichtenstein's oeuvre makes clear that the outline is the foundation of the abstraction of the figures and objects it surrounds. This is especially the case if any supplementary details inside the outline (face, body) are deliberately toned down or eschewed, as is the case in the works of WILLIAM COPLEY; (figs. p.24) they are drawn in a almost naïve manner, right down to wall and fabric décor. Although a style of figure reminiscent of comics can be discerned in his work, the details of the face is often missing in his figures, with their incomplete, animated and thus ornamental outline. The face instead remains blank, an empty space, as if the persons portrayed, at times in compromising situations, are meant to remain anonymous. The degree of abstraction of Copley's figures, innate in his use of outline, accentuates their level of de-subjectivisation, an act that flies in the face of all the rules of classic comic strips.

JOHN WESLEY also structures his pictures »like the comic strip or commercial art, with a purely flat and linear form.«[II] To this end, he uses a very fine outline, whose width varies. His figures, with their allusions to existing comic figures, seem to be the creations of a droll form of Art Nouveau. However, the reduced palette of colours (pale, almost morbid mixed tones) distances Wesley's paintings from the garish colourful world of the comic. Unlike Lichtenstein, he is not interested in the aesthetic ramifications of a media transfer like that of printed lines and Benday dot colour fields, rather he focuses on surface qualities and on latent ornamentality.

The outline style devised by Copley and Wesley in the 1950s and 1960s respectively, and re-encountered in the 1980s, for example, in the figurative wall pieces made from fluorescent tubes of BRUCE NAUMANS, (see fig. 3) emerges as an international trend in the art of the late 1990s. Some

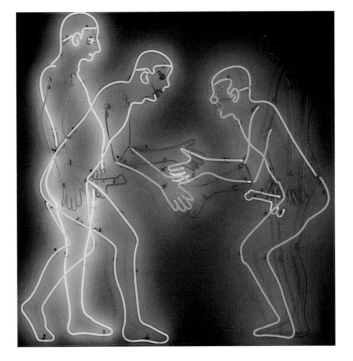

03
BRUCE NAUMAN
Welcome (Shaking Hands)
1985
Staatsgalerie Stuttgart

JULIAN OPIE
Bruce Walking, 2004
Courtesy Galerie Barbara
Thumm, Berlin
CAT. 47 《《

representatives of this middle and younger generation are Michael Craig-Martin, Paul Morrisson, Lisa Ruyter, Eva Marisaldi and Florian Merkel.[12]

The reduction of the outlined figure in JULIAN OPIE's animation (fig. p. 92) goes far beyond that of Copley and Wesley. He links the minimisation of form to an even greater reduction of the line, so that the figures ultimately become pictograms and logos. The stereotyped quality of the figures initially brings Lichtenstein to mind. In the work of Opie, however, the referencing of comic illustrations reproduced in print is not the main focus. Rather, his stylisations reflect the use of the computer graphic program. The graphic act of drawing lines must no longer take place on paper alone, but on the computer screen.

THE DESTRUCTION OF COMIC FIGURATION

THE FIGURES of YOSHITAKA AMANO could be Old Masters in comparison to those of Opie. Amano, also a commercially successful manga and anime illustrator, reflects on and uses

YOSHITAKA AMANO
Landing
2002
Collection Gregory
Papadimitriou, Athen,
courtesy Galerie Michael
Janssen, Cologne
CAT. 1

INKA ESSENHIGH
Mob and the Minotaur
2002
Collection Goetz, Munich
CAT. 26

both his own manga oeuvre for his creative work and the Japanese tradition of Sumi-e: calligraphic drawing that is created through precise gestures.[13] *Landing* (fig. p.95) is proof of his virtuosity and his individual way of developing, using the greatest precision and dynamism possible, a figure and its movements – floating in a colour field – with a fine, almost fragile line. Such mastery recalls the fact that every single comic illustration

DAVID SHRIGLEY
Untitled *(Figure lying on back with spiders)*, 2003
Private Collection, Switzerland
CAT. 86 《

Untitled *(Today my heart is filled …)*, 2003
Collection DuMont Schütte
CAT. 76

Untitled *(Dear mother, I do not like)*, 2003
Collection DuMont Schütte
CAT. 78

(and by extension the line in the comic) is the product of a skilful technique that has been acquired. In most cases, it is prevented from developing in a free or unorthodox fashion, as is the case in David Shrigley's oeuvre (figs. below, left, p.60/61): characters that are clearly delineated and easily recognisable are essential.

As the drawings of David Shrigley's make clear, art after comics must also negotiate the dissolution and rejection of the pictorial and representational conventions developed in the comic strip. The subjective exaggeration and subversion of predefined »linear« comic stereotypes can also be seen in THADDEUS STRODE'S large-format works on paper and in his paintings (figs. p.50, 98–100). As in the drawings of Yoshitomo Nara (figs. p.116–118) or in Marcel Dzama's complex text–image

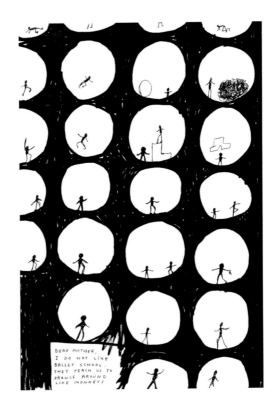

montages, these are subject to their own individual rules and conception of the world that has little in common with the classic comic strip. Raymond Pettibon also subverts the rules of the comic: (figs. p.44–46, 101) the flowing concentration of the brushstrokes reveals the painterly value of his drawings, which as such evolve into graphic painting. Since the texts he inserts into the drawings do not stem primarily from the context of comics, and are also not connected by text balloons to the figures, the addition of different levels leads to a subversion that also has an effect on the apparently comic-like nature of his works.

Playing, at times in an aggressive manner, with the figurative and linear vocabulary of comics is also a key characteristic of the paintings of INKA ESSENHIGH, SUE WILLIAMS and ARTURO HERRERA.

Inka Essenhigh (figs. p.67, 94, 107) cultivates a quite unique form of linear mannerism that stems from her eccentric exaggeration of figurative details, thus augmenting the deformations that often occur in comics and animated cartoons

THOUGHTS ON DUSTY TRAILS.

(THE WILD WEST)

THADDEUS STRODE
Don't Mind, Don't Smell
Bleaching
1994/96
Collection Speck, Cologne
CAT. 88

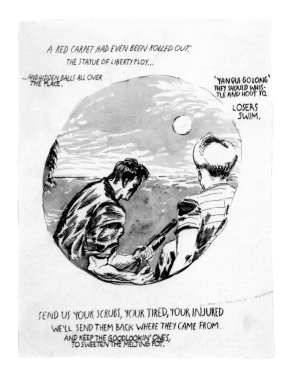

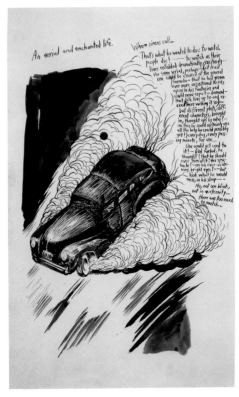

(*Tom & Jerry, Popeye*), particularly during violent scenes. Sue Williams (figs. p. 48/49) creates surreal montages of bodies and parts of bodies that vacillate between abstraction and figuration, using a gestic style of painting that is close to drawing: »The style of drawing is reminiscent of humorous drawings and graffiti, and condenses to form a regular and consistent ›all-over‹, to a dance of lines and shapes that inflate and then taper.«[14] In terms of their net-like texture, the paintings make reference to Jackson Pollock – according to Bice Curiger, they constitute a »subtle condemnation of the masculine painterly tradition of painting.«[15]

Arturo Herrera, (figs. p. 52, 122) on the other hand, annihilates comic figures and their specific linear and flat structure to the point of formal caricature in his collages. The outlines and the figures they delineate dissolve at times. The constituent parts, in a state of extreme elongation, seem to take on a life of their own as abstract flourishes.

On balance, after comics, the line in paintings and in drawings has two faces. On the one hand, the line has shown that it is indebted to the reproduced outline that is a formal prerequisite of any comic strip. The painted line here cannot be understood – as was the case with the Abstract Expressionism of the 1950s – as a sign of subjective expres-

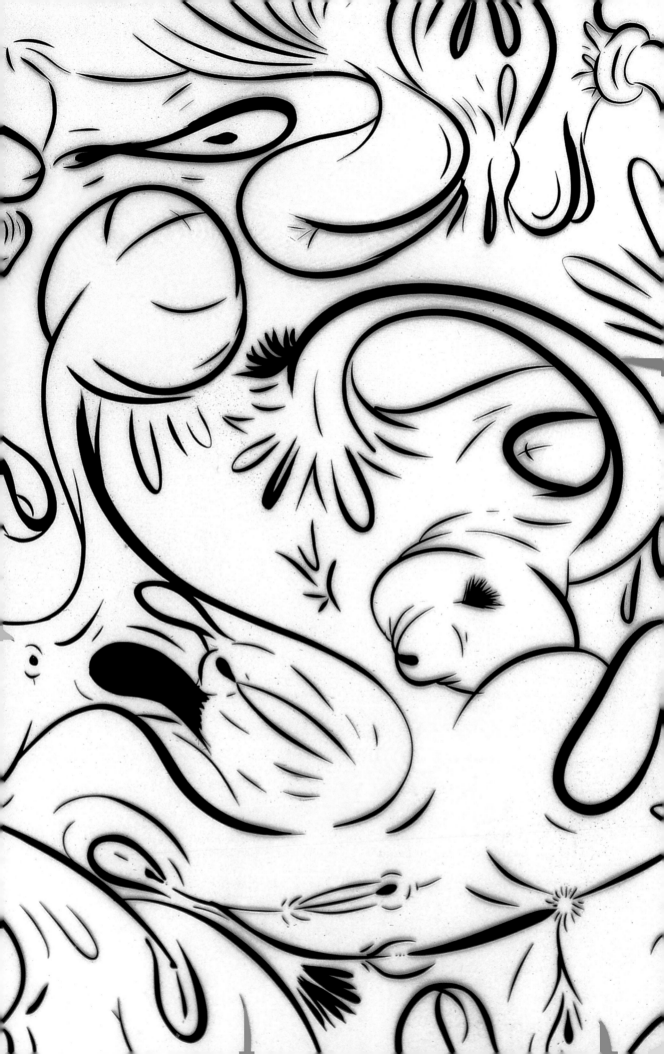

sion; here it is the deliberate imitation and adaptation of the »abstract«, mechanically produced printed line. This act corresponds to artistic reflection on the media aspect of the comics referred to in the works. On the other hand, the line liberates itself from such reflection on media. Artists who employ the line, endeavour to negate any simple references to comics, or even to go beyond these and devise their own systems of characters and content. It is not the »graphic reproduction« of the outline that prevails, rather, that which is created by hand is the true creative »humus« that precedes the creation of the comic. In both cases, painting cannot avoid critical debate with the stylistic device of the line, so fundamentally important for the pictorial rhetoric of the comic. As a formal leitmotif, the line asserts its stylistic influence, and this is how the line – and not colour – becomes »Superman's Big Sister«.[16]

1 Lawrence Weiner, in: Benjamin H.D. Buchloh (ed.), *Lawrence Weiner – Posters. November 1965 – April 1986,* Halifax/Nova Scotia 1986, p.26.

2 For more on the manual phase of the creation of a comic, see Hergé, »Comment naît une aventure de Tintin«, in: *Le Musée imaginaire de Tintin,* exh. cat., Palais des Beaux-Arts, Brussels, 1979, pp.10–19.

3 See also Berenice Rose, *Roy Lichtenstein. Die Zeichnungen 1961–1986,* exh. cat., Schirn Kunsthalle, Frankfurt a.M./Munich, 1988, cat.2, fig. 58 (pen and ink, 57.1 x 50.5 cm; Collection Ileana and Michael Sonnabend, New York).

4 This print (format: 65.7 x 47.9 cm) appeared in 1975 on the occasion of a Lichtenstein retrospective at the Centre National d'Art Contemporain, Paris.

5 Ralf Christofori, »Colour Me Blind! Malerei in einer visuellen Kultur«, in: Ralf Christofori (ed.), *Colour Me Blind! Malerei in Zeiten von Computer-game und Comic,* exh. cat., Württembergischer Kunstverein Stuttgart, Cologne, 1999, p.22.

6 Lawrence Alloway, *Roy Lichtenstein,* Munich/Lucerne, 1984, p.13.

7 Janis Henrickson, *Roy Lichtenstein,* Cologne, 1988, p.41. For detailed comments on Benday dots, see pp.41–49.

8 See the collection of work on *The Last Supper* (1986): Carla Schulz-Hoffmann (ed.), *Andy Warhol. The Last Supper,* exh. cat., Staatsgalerie Moderner Kunst, Munich, Ostfildern-Ruit, 1997, e.g., cat. 11, 12, 14, 16.

9 See also Christoph Maisenbacher, *An die Wand gesprüht … Schablonengraffiti,* Frankfurt a.M. 1988.

10 The lithograph consists of sequence of three sheets, 100 x 81 cm.

11 Bice Curiger, in: Bice Curiger (ed.), *Birth of the Cool. Von Georgia O'Keefe bis Christopher Wool,* exh. cat., Deichtorhallen Hamburg and Kunsthaus Zurich, Ostfildern-Ruit 1997, p.70.

12 See also, precursors like the British artist Patrick Caulfield (born 1936) and the American Carroll Dunham (born 1949).

13 See Michael Wilson, »Yoshitaka Amano«, (review of the Amano exhibition at Leo Koenig Inc., New York), in: *Artforum* XLI/3 (Nov. 2002), pp.187/8.

14 Bice Curiger (see note 11), p.100.

15 Ibid.

16 This term was inspired by an Ian Dury and the Blockheads song: *Sueperman's Big Sister,* from their 1980 album *Laughter.*

COMICS
MYTHOLOG
MODERN
AGE

MYTHS IN A

RATIONALISED WORLD

ULRICH PFARR

AS
Y OF THE

IF COMICS HAVE INDEED TAKEN OVER THE FUNC-
TION OF BEING A SOURCE OF IDENTITY, ONCE HELD
BY WESTERN ANTIQUITY, THEN ARE SUPERMAN,
BATMAN AND CO. REINCARNATIONS OF CLASSICAL
HEROES LIKE HERCULES, JASON OR ODYSSEUS?

EVERYWHERE, the talk is of »new myths« and the intellectual and anti-intellectual »de-struction of myths«. When a magazine like *Le Nouvel Observateur*[1] devotes a special issue to the »mythologies of the present«, and on the title page, lists Kate Moss, the 35-hour week and the condom, one could be forgiven for discerning a degree of arbitrariness in the choice. Admittedly, the magazine makes reference to Roland Barthes' famous essays in *Mythologies*, where he analysed such disparate items as Greta Garbo's face, the »Jet man« and the Citroën DS.[2] On the magazine cover is the supermodel Moss, who, elevat-ed by fashion and photographers, embodies the myth of the new woman. In her fishnet catsuit, she is the female counterpart of Spiderman, a comic hero who has recently re-ceived a digitally perfected new lease of life in film. Prior to the release of the block-buster *Spider-Man II*, Spiderman's red-and-black costume, reminiscent of the comic's appealing primary colours, was to be seen on billboards all over town. Barthes defined

the myth as »a secondary semiological system«, as a metalanguage that parasitically appropriates the meaning of the signs of a language (or of another »primary system«, for example, the military, sport), in order to establish a concept for its addressees. In other words, this process transports an ideological meaning whose random message appears natural, although it is actually only used as a *form*. Unquestionably, this describes shifts in meaning that are quite customary in advertising, politics and art.

The chain of mythological signs imparts an existence to the media-based figures of today that is independent of any comics, films, video games or human actors.[3] In this way, these figures attempt to achieve the sublime character of the myths of the Ancient Greeks and Romans, or of those traditional cultures on the margins of the known world, which have long been incorporated into the global media. While in a disenchanted world, mythologies have negative connotations; in the compensatory spheres of art and the mass media they receive the status of inviolable and immutable assets.

In fact, even Greek philosophy distanced itself from the traditional mythologies that formed the basis of the Homerian epics and classical tragedy. Since the 6th century B.C., myths have been increasingly regarded as fables or fairytales; only justifiable as a way of preserving prehistorical knowledge in a child-friendly form, or as a pedagogically useful prelude to serious philosophy.[4] Taking the conceptual pair »myth–logos« as their point of departure, modern thinkers contrasted the pictorial imagery of mythical thought with the clarity of conceptual thought. The value of myth, however, was restored by the Romantics; Herder called them the expression of the childlike dreams of the human soul.[5]

From such a vantage point, the myths of classical antiquity are indeed related to comics. One need think only of the infantile universe of Donald Duck, where the realities of sexuality remain obscure and gender differences are translated into idiosyncratic natural laws. However, drastic sexual acts, even those circumscribed by the strongest of cultural prohibitions, are by no means unusual in traditional, and, especially, in cosmological narratives. This created the basis for the psychoanalytical opinion that such acts are still present on a symbolic level in the subconscious fantasies of modern neurotics.[6]

Since the 1960s, such elements have resurfaced in provocative underground comics, which deliberately break cultural taboos and subvert the censorship laid down in the Comic Code Authority introduced in the United States in 1954. The archaic cruelty innate in many myths also finds a counterpart here. In the horror and war comics of the 1950s, in the *Batman* series, which became more brutal as time went on, and in some underground comics, the scale of violence increased. Brutal combat and scenes of killing are indeed constitutive of the confrontation between Good and Evil in the Japanese *Shonen* manga: pictorial worlds that convey the friendship ideals and phantasms of the dominant masculine culture to Japanese boys on the verge of adolescence. Despite the

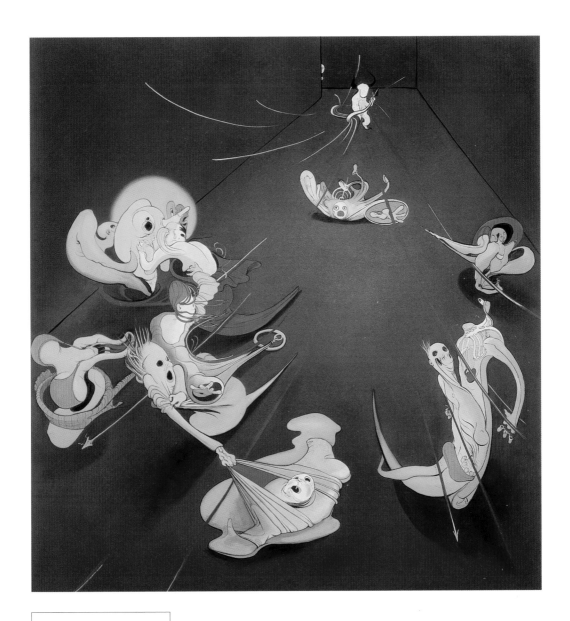

INKA ESSENHIGH
Arrows of Fear
2002
Collection Goetz, Munich
CAT. 24

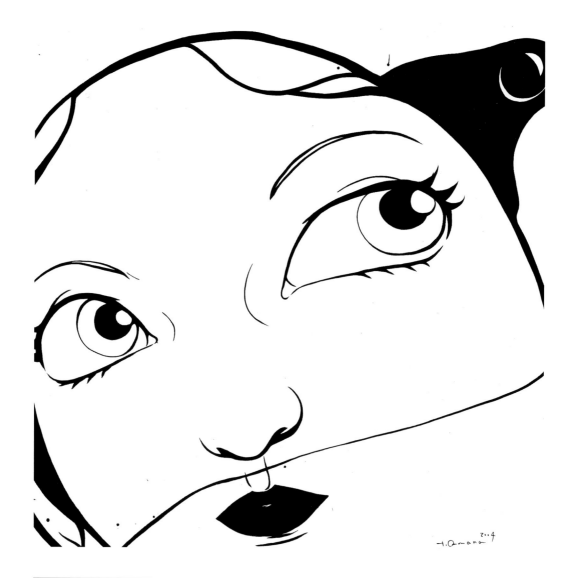

filmic close-ups and the employment of other realistic means, the fictional properties of the manga, like those of the anime, are reflected in the decidedly conventional nature of such scenes.[7] In 1954, the US Senate commissioned a study examining the links between youth criminality and the harmful impact of reading comics; today, the medium receives broad approval from society.

Although the irrational danger inherent in myth is often emphasised, increasingly, so too are its positive powers. The mythic does not necessarily have to mean the confrontation of concrete reality with a static order that conceals power structures and evades criticism: the reason for the Enlightenment response to myths of exposing them and showering them with derision. Rather, it can also be a means to oppose bondage

and lack of rights, as in the work of Ernst Bloch,[8] or as an imaginative way of trying out alternative systems, as is often the case in the use of myth in contemporary literature.[9] Feminist authors, in particular, not only deconstruct myths, but also use them as a space for projection. Living mythologies are polymorphic and are always open to new interpretation.

SUPERMAN AS THE NEW HERCULES?

At the point when humanist education no longer has any relevance, then the mythology of classical antiquity also loses its validity for European culture. The commercial mainstream has taken its place, engulfing every »classical« domain. Comics can well be used to teach traditional ideas and content, but the so-called »tract« comics, including comic bibles and political programs packaged as picture stories, function merely as Trojan horses. Comics that successfully take from classical antiquity do not necessarily pursue didactic aims; rather, they make use of the freedom offered by the medium to embark on fantastic journeys to distant times and places.[11] Indeed, the caricatures of antiquity of the 18th and 19th centuries tamed and thereby trivialised educational material that used sources from antiquity, and as such, pre-empted today's comics on two levels. The success story of the new medium can indeed by classified as being part of the Americanisation of world culture.

Pictorial stories, in contrast to aggressive caricature, were expected to have a socially cohesive function at a very early stage.[11] The picture stories produced in the United States as colour supplements in newspapers around 1900 have, in retrospective, been associated with the emergence of a shared national identity in an ethnically diverse society of immigrants.[12] These early comics clearly addressed an adult audience, as do Volker Reiche's comic strip *Strizz* in the *Frankfurter Allgemeine Zeitung* and Gary Trudeau's *Doonesbury* strip in the *Guardian*. In the absence of a shared educational background, the immigrant groups – and this is also the situation in Europe today – found a new platform for com-

Superman Fights to
Save Planet Earth
in: Superman against
Schazman
1979
FIG. 1

COMICS AS MYTHOLOGY OF THE MODERN AGE

<< P. 110/111

ERRÓ
Comicscape
1972
Collection Loevenbruck, Paris
CAT. 23

munication in the comic strips. The Sunday supplements were not committed to any educational goal; instead they offered easily digestible entertainment as part of their battle to win readers. In doing so, they created a space for popular culture that came closer to real private life than the business or political news. The success of this hedonistic medium led to the rationalisation of its production: division of the labour workflow increased. Picture strips aimed at children and young people, and, in particular, action and detective strips that enjoyed years of popularity emerged. They offered prime material for the debates on »dirt« and »depravity« that were sparked by early film reviews and their influence was apparent in sociological research into comics until very recently.[13]

If comics have indeed taken over the function of being a source of identity, once held by Western antiquity, then are Superman, Batman and co. reincarnations of classical heroes like Hercules, Jason or Odysseus? This has been a subject of discussion in the English-speaking world since the 1940s, as superheroes evidently follow in the footsteps of pagan or Christian saviours and act as guardian angels on the edge of mortal life (see fig. 1).[14] In the work of MEL RAMOS, we encounter *Captain Midnight* (fig. right), the fierce, sharply drawn eponymous hero of a comic strip from the 1940s and 1950s, which drew its material from the mythical air battles of the two world wars. The comics and the corresponding films made at the time were all based on a series of radio plays broadcast by the WGN station in Chicago from 1938, whereby his sinister adversary Ivan Shark changed in the course of time from a criminal-cum-Communist into a German Nazi who threatened the entire world. Fully in keeping with what Barthes termed the »hagiographic« era of propeller flight, which was defined by the heroism of daring individualists,[15] Ramos portrayed Captain Midnight as a saint; framed in a medallion, from which his right hand seems to be reaching out. The iconographic attributes of the pilot – goggles, leather flying helmet, and cartridge belt – are not only presented as indicators of Captain Midnight's heroic deeds but also as the instruments of his suffering, borne out by his physical commitment, and evidenced even by his facial expression. Unlike other superheroes, Captain Midnight did not possess any superhuman abilities; like the later James Bond, he was superior by dint of his mastery of his plane, secret special weapons, and not least, the use of a decoder: Ramos portrays this as an emblemic dial with a dual scale on portrays Captain Midnight's chest. The stylisation of Captain Midnight as a hypermasculine, angular muscleman and Ramos' use of colour evoke further associations with the iconography of Superman. They help the figure to transcend his historical roots – clearly encoded through the US fighter plane in the background – into a transhistorical and de-individualised being.

Can a religious significance be attributed to these comics? Do they proclaim any salvation or creed? The most popular figures in classical mythology were merely descended

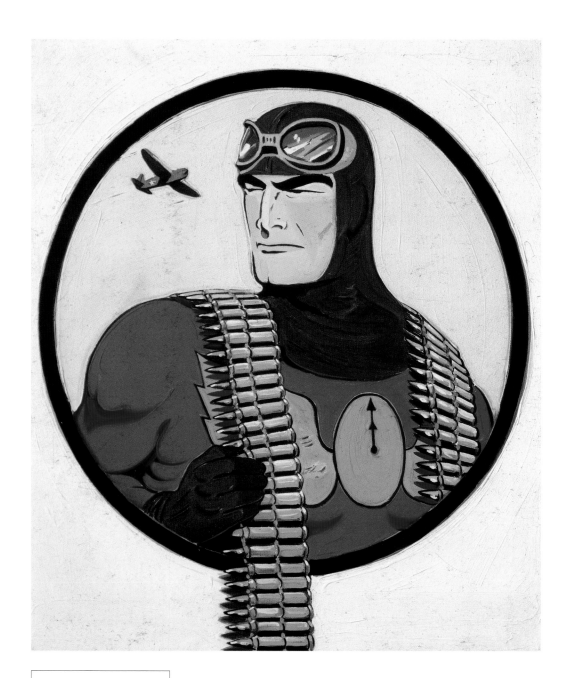

MEL RAMOS
Captain Midnight
1962
Mel Ramos
CAT. 66

from the Gods, and themselves only became gods after death. The Christian saints differ from lesser mortals by dint of their nearness to God; they possess an especial potential enabling them to act as intermediaries between the spheres. Superman, in particular, bears many of the traits of Hercules, that saviour and paragon of virtue from classical antiquity whom the Renaissance considered a precursor to Jesus.

Superman's ability to fly, which has been passed on to the manga hero *Astro Boy* (see fig. 2), for example, corresponds to that of Hermes, the messenger of the gods. Nevertheless, the secular origins of Superman are established in a twofold manner: his marvellous powers receive the pseudo-rational explanation of being the product of his birth on the planet Krypton, and his inventor, Jerry Siegel, declared that Superman was a concentrated version of »Samson, Hercules, and all the strong men of whom I have ever heard.«[16] There could hardly be a more unambiguous way of stating the fact that Superman has no eschatological meaning. On his home planet, whose destruction he narrowly escaped, Superman would only have possessed average powers because of the stronger gravitational forces.

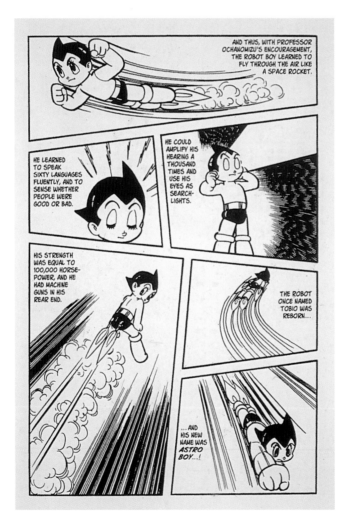

The birth myths of other heroes are similar in content: Spiderman was bitten by a radioactive spider (see fig. 3), which gave him supernatural powers; Astro Boy is the product of a robot factory owner, in other words, a failed product that has taken on a life of its own. In all of these cases, the heroes result from accidents and disasters, which, nevertheless, attest to an optimistic vision of technology. To follow Barthes, who states that myth deforms but does not conceal, at this end of the semiotic chain, we can dis-

Astro Boy
© Tezuka Productions
FIG. 2

cern the 20th century's emphatic belief in progress. The belief in the technical feasibility of the most daring of fantasies is innate even in its negative variant: the struggle between comic heroes and scientists who have gone crazy and who threaten life on earth. While the film *I Robot* (2004) departs from the Isaac Asimov novel on which it is based, and offers yet another variation on the Frankenstein myth of the artificial human who turns on his creator; since 1951, *Astro Boy* has represented the utopia of reconciliation between humans and intelligent robots.[17]

The fact that the original version of Astro Boy, published in the country of Hiroshima and Nagasaki, bore the name *Tetsuwan Atom* (powerful atom), points to an attempt to show that, despite justifiable fears, the use of nuclear power is harmless. In this respect one has to admit: The myths of the present day are to be found in comics.[18] Although modern heroes are no longer modelled on the heroes of Ancient Greece, as was Superman, their references to contemporary science fiction comics,[19] also show the importance of the myth of technology; which is, per se, no more rational than the myths it replaces. Yet it is not least the vision of a synthesis of robot technology and humanity that provides material for the creation of artistic myths.

COMICS AS MODELS FOR POLITICAL ACTION

THE FACT THAT COMICS are now distributed worldwide would speak for the re-examination of their mythic potential. This distribution has gone hand in hand with a differentiation that has been especially pronounced in Japanese manga culture. In addition to the mostly black-and-white comics that are published at regular intervals, elaborately designed art books do full justice to the cult status of particular comic series and figures and to the fame of their creator. The environments created by YOSHITOMO NARA using drawings and objects (figs. p. 116–118) reflect the extent to which everyday Japanese culture has been permeated by the manga phenomenon; the influence of comics on other visual media is not noticeably less in the United States and Europe. In this context, the significance of comics for politics bears mentioning. There are certainly paral-

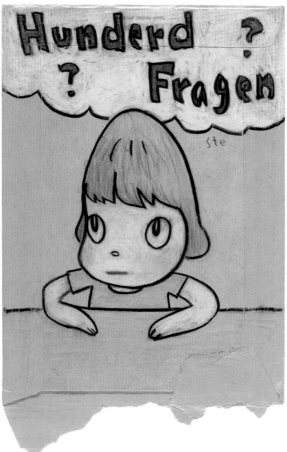

YOSHITOMO NARA
Heading to Wall
2004

Hunderd Fragen
2004

Untitled
2004 »

Diebe sind im Haus.
2004 »

Courtesy Galerie Zink und
Gegner, Munich
CAT. 46

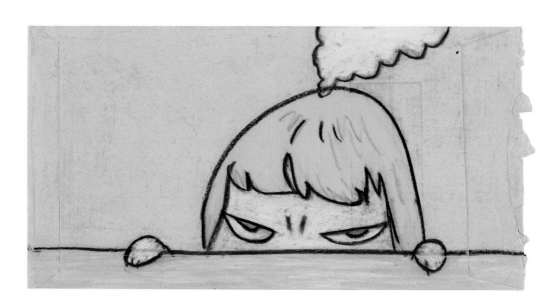

lels between Superman's constant mission and the world power whose entire foreign policy is currently dedicated to the battle against Evil. It will therefore come as no surprise that the US President staged his landing on the aircraft carrier USS *Abraham Lincoln* on May 2, 2003 in the role of a superhero descending from heaven, thus making his proclamation of the end of fighting in Iraq more credible. The garish blue-and-yellow outfit of the parachuting German politician Jürgen Möllemann, acting Superman for his liberal party the FDP, actually bore the words »Mich schickt der Himmel« (Sent by heaven). Do they not resemble (at least in the eyes of those members of the general public fascinated by them) the jet pilots of Barthes who were all »rei-

fied heroes, as if even today men could conceive the heavens only as populated with mythical beings?«[20]

With regard to such interrelations, comics are increasingly being seen as a medium of communication. Their authors, usually recruited from the ranks of youthful fans, keep close contact to fan communities via readers' letters, fanzines and chat forums on the Internet. However, any arguments supporting the comic–myth hypothesis have been systematically »disproved« by Hausmanninger. Hausmanninger[21] studied how the Su-

perman comic strip, which has been running for decades, dealt with the current issues and sentiments of American society, and also how the comic strip has constantly adapted to fit the general political context.[22] Although, the comic strip does not have a fixed ideology, the changing messages it conveys do not preclude an ideological function.

Superman does not always convey a Manichean view of the world in which Good and Evil confront each other in unadulterated form. Originally, he acted of his own volition and exploited every opportunity to try out his superpowers, fighting and punishing criminals with no regard for the law. Then, during the Second World War, he enlisted in the US Army and so subordinated himself to the President. In the post-war period, he even had to be re-socialised, as his supertough hair posed problems for the barber, which unintentionally made Superman resemble those statues of Hercules carrying out heroic deeds, muscular to the point of caricature.

In the 1960s, Superman found himself in an identity crisis: citizens' groups rendered the intervention of higher powers superfluous leaving him jobs like rounding up bugs at superspeed. Additionally, the introduction of social themes moved the causes of criminal behaviour into focus. The message of the comic did not assume fascistic tendencies again until the 1980s, in the age of Ronald Reagan, who based his policies on the incontrovertible existence of an »Empire of Evil«.[23] Ideological structures are exhibited even more overtly in Franco-Belgian comics than in American ones; the former did not lose their force until new genres emerged in the 1980s.[24] The mythological statements made by politically loaded comics focused, for example, on the threat of US-American domination, French colonialism, or the destruction of French culture, and in each case, fuelled fears of conspiracies that were always clearly discernible variants of the »Communist threat«.[25]

In particular, the manner in which two Marvel comics addressed the terrorist attacks of September 11, 2001 appropriates the ontologisation of Evil from earlier epochs of superheroes comics. The traumatic events of 9/11 have created a form for the Manichean world of the imagination where Batman and other superheroes can be transposed into reality and be placed, not only among the ranks of the police and rescue forces of New York City, but also where the nimbus of mythical figures can be transferred onto ordinary people; they are all heroes; they battle against indefatigable Evil. The absence of language in the Marvel comic *A Moment of Silence* removes any mythical escape route or meaning from an event that immediately led to the creation of numerous new myths. In this way, the politics of wordlessness discredit democratic discourse: action not words is the covert message.

It is perhaps true that the potential of the myth to provide insight into itself, emphasised by Max Horkheimer and Theodor W. Adorno, may well have been activated for the first time in the artistic creation of myths in comics.[27] When the cartridge belt of *Captain Midnight* projects out from the edge of the circular picture frame, then Ramos

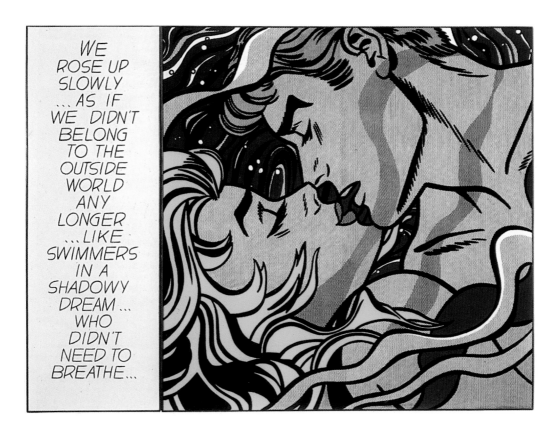

creates a fissure in the structure of the image that could be a connection to the next frame of the comic strip. In many mangas, bridges between the panels serve, by contrast, to dissolve the linear sequence of the narrative. ÖYVIND FAHLSTRÖM used similar means to link pictorial fields and word bubbles into systems of receptacles that illustrate the connections within and between political and economic systems. Ramos uses Midnight's hand to indicate the message of his cartridge belt, and this, in turn, refers two reflexible messages to the reader: the modernised message of salvation in the form of the victory of Good over Evil, and the myth of aerial combat, where soldiers truly prove and even enhance their masculinity. Here, sexuality becomes a metaphor for the power of their weapons and not vice versa.

Further war myths are to be found in the works of ROY LICHTENSTEIN; he backdated contemporary comics from the time of the Second War in Indochina to the time of the long-mythologised Second World War. Lichtenstein's strategy of the single-frame image, for example, *Takka Takka* (fig. p. 21), is used to isolate the *exalted code* of the war comics – dramaticisation using lines of movement, onomatopoeia, etc. – from the action and give these signs a life of their own. As the human actors have been eliminated from the noisy machinery of war, the statements in the texts refer solely to themselves. This shows the

ARTURO HERRERA
Untitled
1997/98
Owned by artist, courtesy
Brent Sikkema, New York
CAT. 30

critical strength of the work: in these pictures, the values inculcated by countless tales of war – unflinching willingness to fight and sacrifice – lose all their meaning.

Circular references also underlie the works of Lichtenstein that deal with romantic love: the central myth of the world of the media. Through the aesthetic purification of individual images that he has isolated from mass-market love stories, it becomes clear that the emotions constructed in the action of the comics belong to a secondary culture. The viewers of *We Rose Up Slowly* (see fig. 4) see text and image compared as objects; beyond the frame of the respective »script«, the stereotypy of the proposed gender roles, and the sterility of the immersion in the hermetic maritime world of the lovers become clear. The inner emptiness of these clichéd figures becomes manifest through their magnification. And yet, this emptiness is the condition of their emotional efficacy, as only then can they attract the personal projections of readers. The painting reminds us of events structured by pictorial novels, corresponding films, and advertisements, and so a closed cycle of reproduction occurs.

Pop Art's strategy of appropriation was not without consequences. While works by Lichtenstein or Ramos can be attributed to specific sources, ARTURO HERRERA utilises a Disney-like style of drawing for his creations without ever clearly attesting to specific sources (figs. left, p. 52). This artistic semanticisation of references from comics triggers a mythological chain of signs that refers to purely imaginative qualities; in the words of Barthes: myth is the sole signifier of these signifieds.

The movement and transformation of signs within the artistic process must therefore be considered a central aspect of the mythical. By processing myth, current issues are addressed, as is the case in the creative work of YOSHITAKA AMANO, who draws animated films (figs. p. 95, 108, 125). He transposes the flickering, dynamically distorted figures of Japanese pop culture, culled from the world of electronic and digital media, into the ink brush and rice paper world of Sumi-e art, a genre of calligraphic art that came to Japan from China in the 14th century. The lines conveying perspective and movement are transformed by Amano into the traditional aesthetics of empty space; in this way, his figures have a sense of timeless existence, preserved in collective ideas.

Although researchers focused for many years on mythical interpretations of superheroes, the mythical potential of comic worlds also stems from their intermediary function: mediation between everyday life and the imagination. The *Little Nemo in Slumberland* comic strip (see fig. 5), which was published from 1905 to 1911 in Sunday colour supplements in New York newspapers, demonstrates this well. WINSOR MCCAY expands his young hero's bedroom into a space for the wishes and fantasies of his

dreams; their dramatic intensification regularly causes the action to flip over into terrifying nightmares. These dreams represent the intrapsychological events of Nemo's education: the pleasurable exaggerations and excesses prompt a punishing force to emerge, which then imperceptibly seizes control of the dreams. It is these »depths« that create the humour of the comic strip.

A moral structure, such as this, that repeatedly confines the hero within the limits of his own pettiness and helplessness, is a device that is also used in connection with modern superheroes. Tobey Maguire, the hero of *Spider-Man II*, emphasises that one of the advantages of Spiderman is that essentially he has the same problems as the average film-goer, for example, worrying about paying the rent. This addresses the characteristic dual identity of superheroes who link imaginary and social reality. This model enables comics to contribute to the creation and expansion of an inner psychological domain that is imperative for the growth of social and emotional skills.[28]

Beyond his life as a superhero, Superman also leads a profane existence as Mr Average American, Clark Kent. His superpowers, the product of male fantasies, were expanded to include abilities such as »heat vision«, but he gained few new intellectual skills. In other words, Superman always bore the burden of having to integrate his adventures in the world of marvellous deeds and incredible missions into the mental and emotional mind-set of an average newspaper reporter called Clark Kent. Later comic figures, however, were often granted magical powers or extrasensory perception. Young girls in Japan adore the *Magical Girl* manga: now available in US and European versions and in various TV series.

Fantasies of being able to magically control the world around us not only compensate for the trials of daily life, but, according to Donald Winnicott, fulfil a transitional function for children on the threshold to puberty. However, in comics, the abilities that cor-

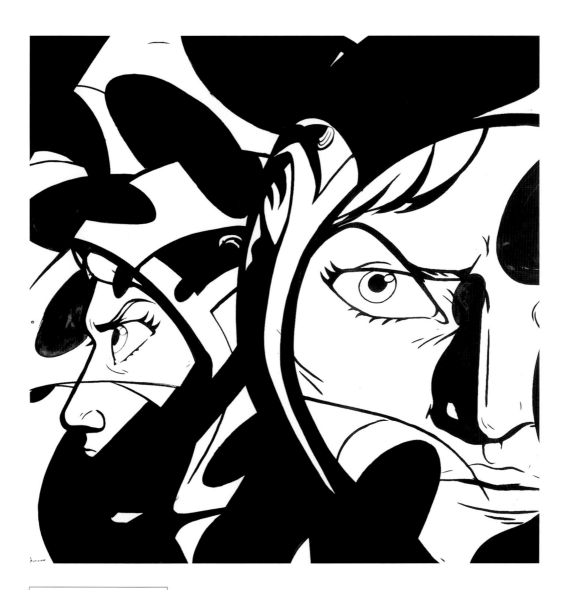

YOSHITAKA AMANO
Untitled
2004
Courtesy Galerie Michael
Janssen, Cologne
CAT. 3

ÖYVIND FAHLSTRÖM
Model for Meatball
Curtain
1970
Collection Falckenberg,
Hamburg
FIG. 6

respond to magical thinking tend to be clad in a pseudo-scientific cloak. These rationalisations characterise the imaginative space of the comic as a continuation of reality – right into the domain of magical wish fulfilment. In this way, comics create a sphere where the division between dream and reality has been removed as are the barriers of real life between the world of children and adults.

This context offers an explanation for the genre of *Shonen-Ai* mangas, which ostensibly deal with homosexual love between boys. These are a more recent variant of the *Shojo* manga, which date back to the 1950s and were addressed to girls. The *Shonen-Ai* mangas enable projected wishes and conflicts to be explored vicariously, in other words, wishes and conflicts that have, in the terms of the clinical psychoanalytical definition of projection, been severed from our self-image. These comics tend to ease the path of their female readers towards sexual maturity. The psychological perspective may also offer a way of understanding Nara's work: his figures, which depend on the »little kid

ROBERT CRUMB
Meatball
Section
1968
FIG. 7

image« do not actually possess the high kawaii factor they suggest, and so undermine saccharine notions of childhood developed by adults from a safe distance. Thus, Nara not only undermines the characteristics that are clearly used to legitimate the strict division between childhood and adolescence in Japan, his pavilions also create an alienated atmosphere of a child's room, where the vital autonomy of his figures asserts itself against the obsessive desire of society for an artificial childhood, as characterised by the manga phenomenon. Here, the categories of mythical space and the creative sphere meet in an accessible real space.

In his playful installation *Meatball Curtain (for R. Crumb)* from 1969, Öyvind Fahlström lends a scenic quality to cutout silhouettes (see fig. 6). A homage to Robert Crumb , pioneer and cult figure of underground comics, this piece refers to Crumb's ironic diagnosis of American life in his comic strip *Meatball* (see fig. 7), which appeared in 1968 in *ZAP Comics*; meatballs falling from heaven hit the unsuspecting on the head and trigger euphoric revelations and awakenings that end by shaking up public order.

TIM EITEL
Sailor Moon, 2001
Art Collection of the
Sachsen LB
CAT. 21

Here, Crumb could be seen as portraying the fantasy of the

entire middle-class joining the hippie movement. Fahlström renders the raining meat-balls three-dimensionally, and expands the cutouts to include political and social symbols, thus inserting Crumb's subversive images into a global logic: blue represents the Western world, red and yellow the Communist bloc, green and brown the Third World. Yet the two-dimensional objects and figures oscillate between the presence of the image and the referential function of the written word; the variable references here engender an interpretative field in which no single meaning can be defined as the right one. The concentration of the regressive–corrosive and utopian–constructive powers of the comic displays, as do the works in the exhibition, a gaiety within which Enlightenment and Mythology are no longer oppositional.

1 *Le Nouvel Observateur,* Hors-Série No.55, July/August, 2004.

2 Roland Barthes, »Mythologies, suivi Le Mythe aujourd'hui«, 1954–57, in: *Œuvres complètes,* vol.1, Paris 1993, pp.561–722. Selected texts in *Mythologies,* trans. Annette Lavers, Jonathan Cape, London, 1972.

3 »We must here recall that the materials of mythical speech (the language itself, photography, painting, posters, rituals, objects, etc.), however different at the start, are reduced to a pure signifying function as soon as they are caught by myth«. Mythologies, p.114.

4 Walter Burkert, s.v. »Mythos« and »Mythology«, in: *Historisches Wörterbuch der Philosophie,* vol. 7, 1984, columns 281–283.

5 Axel Horstmann, ibid., columns 283–295.

6 Cf., Donald Kuspit, »A Mighty Metaphor: The Analogy of Archeology and Psychoanalysis«, in: *Sigmund Freud and Art,* Lynn Gamwell and Richard Wells (eds.), London, 1989, pp.133–149.

7 The »anime laws« on the fansite at manga.li attest to the irony of their authors.

8 Ernst Bloch, »Zerstörung, Rettung des Mythos durch Licht«, in: *Literarische Aufsätze,* Frankfurt a.M. 1965, pp.338–347.

9 Cf., Nicola Bock-Lindenbeck, *Letzte Welten – neue Mythen,* Cologne, 1999.

10 Cf., Tomas Lochman (ed.), »Antico-mix«. *Antike in Comics,* Basel, 1999.

11 See also Kirk Varnedoe and Adam Gopnik, *High & Low: modern art, popular culture,* Munich, 1990, p.111, note 1.

12 See David Pascal, »Comics: Ein amerikanischer Expressionismus,« in: *The Art of the Comic Strip,* David Pascal and Walter Herdig (eds.), Zurich, 1972, pp.80–87.

13 Thomas Hausmanninger, »Können populär-visuelle Medien emanzipativ sein?« in: *Comics zwischen Zeitgeschehen und Politik,* T. Hausmanninger and H. Jürgen Kagelmann (eds.), Munich/Vienna, 1994, pp.13–43.

14 Cf., Elaine Caruth, »Hercules and Superman«, in: *Journal of the Academy of Child Psychiatry,* 7, 1968, pp.1–12.

15 »The Jet man«, (see note 2), pp.71–73.

16 Thomas Hausmanninger, *Superman. Eine Comic-Serie und ihr Ethos,* Frankfurt a.M., 1989, p.60.

17 Paul Gravett, *Manga: Sixty Years of Japanese Comics,* London, 2004, p.32f.

18 See also P. Quennell, »Comic strips in England: future ethnologists will find them in the mythology of the present day,« in: *Living Age 360,* 1941, pp.21–23.

19 See also James Steranko, *The Steranko History of Comics,* Reading, 1970, pp.37–39.

20 »The Jet man«, (see note 2), p.73.

21 »Der Superheld als Mythos? Aufräumarbeiten mit einer These«, in: *Comics Anno 1,* 1991, pp.42–84.

22 Hausmanninger (see note 16).

23 Ibid., especially pp.77, 79, 133, 210.

24 Georg Seeßlen, »Klare Linien, dunkle Träume. Politik und Zeitgeschichte in den franko-belgischen Comics«, (see note 13), pp.100–115.

25 Cf., Reinhard Schweizer, *Ideologie und Propaganda in den MARVEL-Superheldencomics. Vom Kalten Krieg zur Entspannungspolitik,* Frankfurt a.M., 1992.

26 Cf., Stefanie Diekmann, »Hero and Superhero«, in: *The Guardian*, April 24, 2004.

27 See also Max Horkheimer and Theodor W. Adorno, *Dialectic of Enlightenment,* trans. J. Cummings, Verso, London, 1979, esp. pp.3–9.

28 Cf., Caruth (see note 14), p.3; and Franz C. Kinzel, »Eine Metaanalyse von Comics aus psycho-analytischer Sicht«, in: *Comics Anno 3,* 1995, pp.140–167.

PHOTO CREDITS

WORKS IN THE EX-HIBITION

YOSHITAKA AMANO

1952 born in Shizuoka City, Japan
lives in Tokyo, New York and Paris

Landing, 2002
Acryl and car lacquer on aluminium board
200 x 200 cm
Collection Gregory Papadimitriou, Athen,
courtesy Galerie Michael Janssen, Cologne
cat. 1 | fig. p. 95

Untitled, 2004
Acrylic on canvas
195 x 195 cm
Courtesy Galerie Michael Janssen, Cologne
cat. 2 | fig. p. 108

Untitled, 2004
Acrylic on canvas
195 x 195 cm
Courtesy Galerie Michael Janssen, Cologne
cat. 3 | fig. p. 125

IDA APPLEBROOG

1929 born in New York, lives in New York

Not This Time, 1982
Ink and rhoplex on vellum, in plexiglass case
38,5 x 239 x 4,5 cm (plexiglass case)
Owned by artist,
courtesy Barbara Gross Galerie, Munich
cat. 4 | fig. p. 50/51

Say Something. A Performance, 1977
Artist's book, edn.: 132/500
12 pages, signed, dated
19,8 x 15,7 cm
Staatsgalerie Stuttgart, Archiv Sohm
cat. 5

I'm not your Son. A Performance, Act 2, 1977
Artist's book, edn.: 180/500
12 pages, signed, dated
19,8 x 15,7 cm
Staatsgalerie Stuttgart, Archiv Sohm
cat. 6

Where do I come from? A Performance, 1977
Artist's book, edn.: 484/500
12 pages, signed, dated
19,8 x 15,7 cm
Staatsgalerie Stuttgart, Archiv Sohm
cat. 7

The Sweet Smell of Sage. A Performance, 1979
Artist's book
12 pages, dated
19,8 x 15,7 cm
Staatsgalerie Stuttgart, Archiv Sohm
cat. 8 | fig. p.91

I Feel Sorry for You. A Performance, 1979
Artist's book
12 pages, dated
19,8 x 15,7 cm
Staatsgalerie Stuttgart, Archiv Sohm
cat. 9 | fig. p.91

Sure I'm Sure. A Performance, 1979
Artist's book
12 pages, dated
19,8 x 15,7 cm
Staatsgalerie Stuttgart, Archiv Sohm
cat. 10

GIANFRANCO BARUCHELLO
1924 born in Livorno, lives in Rome

La Correspondence, 1976
Gloss paint on aluminium
100 x 100 cm
Städtische Galerie im Lenbachhaus, Munich
cat. 11 | fig. p.30

PETER BLAKE
1932 born in Dartford, Kent, lives in London

Children Reading Comics, 1954
Oil on hardboard
36,9 x 47 cm
Tullie House Museum and Art Gallery, Carlisle
cat. 12 | fig. p.14

ANGELA BULLOCH
1966 born in Fort Frances, Kanada,
lives in London and Berlin

From the S/M Series, 1992
10 black and white photographs
20,8 x 21,8 cm; 44 x 31,8 cm; 54 x 23 cm; 22,7 x
43,8 cm; 38,2 x 41,5 cm; 26,5 x 17 cm; 20 x 15,5 cm;
43,8 x 24 cm; 52 x 27,5 cm; 26,5 x 17 cm (framed)
Collection of the Landesbank Baden-Württemberg
cat. 13 | figs. p.58/59

**AUGUSTO DE CAMPOS, DÉCIO PIGNATARI,
HAROLDO DE CAMPOS**

*Teoria da Poesia Concreta. Textos Críticos e
Manifestos 1950–1960*, 1965
Edições Invenção, São Paulo 1965
Staatsgalerie Stuttgart, Archiv Sohm
cat. 14 | fig. p. 37

WILLIAM COPLEY

1919 born in New York, 1996 died in Key West, FL

Untitled, 1971
Black Indian ink on cardboard
73,9 x 58,7 cm
Staatsgalerie Stuttgart/Graphische Sammlung
cat. 15 | fig. p. 24

Man & Woman going to Bed without Each Other, 1991
Black felt tip over pencil on paper
46 x 59,9 cm
Staatsgalerie Stuttgart/Graphische Sammlung
cat. 16 | fig. p. 24

GUY DEBORD

1931 born in Paris, 1994 died in
Bellevue la Montagne

internationale situationniste, 1958-69
no. 5, Dec. 1960; no. 8, Jan. 1963;
no. 10, March 1966
Ed. by l'internationale situationniste
Staatsgalerie Stuttgart, Archiv Sohm
cat. 17 a–c | fig. p. 32/33

GUY DEBORD AND ASGER JORN

1931 born in Paris, 1994 died in
Bellevue la Montagne
1914 born in Vejrum, Denmark, 1973 died in
Aarhus, Denmark

Fin de Copenhague, 1985 (reprint from 1957)
Staatsgalerie Stuttgart, Archiv Sohm
cat. 18 | fig. p. 37

Mémoires, 1959
Book, ed. by l'internationale situationniste
Staatsgalerie Stuttgart, Archiv Sohm
cat. 19

MARCEL DZAMA

1974 born in Winnipeg, Kanada, lives in
Winnipeg, Kanada

Die verloren Seelen von die Diskothek, 2004
Indian ink and watercolour on paper
In 7 sections, 35,6 x 195,3 cm (in total, framed)
Private collection Dusseldorf, courtesy
Sies + Höke Galerie, Dusseldorf
cat. 20 | fig. p. 62/63

TIM EITEL

1971 born in Leonberg, lives in Leipzig
and Berlin

Sailor Moon, 2001
Oil on canvas
180 x 250 cm
Art Collection of the Sachsen LB
cat. 21 | fig. p. 127

Murakami, 2001
Oil, acrylic on canvas
150 x 150 cm
Art Collection of the Sachsen LB
cat. 22 | fig. p. 77

ERRÓ (GUDMUNDUR GUDMUNDSON)

1932 born in Olafsvik, Iceland, lives in Paris

Comicscape, 1972
Oil on canvas
200 x 300 cm
Collection Loevenbruck, Paris
cat. 23 | fig. p. 110/111

INKA ESSENHIGH

1969 born in Belfonte, PA, lives in New York

Arrows of Fear, 2002
Oil on wood
178 x 190 cm
Collection Goetz, Munich
cat. 24 | fig. p.107

Airport Painting, 2003
Oil on canvas
178,5 x 188,5 cm
Collection Goetz, Munich
cat. 25 | fig. p.67

Mob and the Minotaur, 2002
Oil on wood
183,1 x 214 cm
Collection Goetz, Munich
cat. 26 | fig. p.94

ÖYVIND FAHLSTRÖM

1928 born in São Paulo, 1976 died in Stockholm

The Cold War, 1963–65
Variable diptych, tempera on vinyl, metal,
plexiglass, magnets
In two sections, each 244 x 152,5 x 2,5 cm
Musée national d'art moderne, Centre Georges
Pompidou, Paris
cat. 27 | fig. p.36

RICHARD HAMILTON

1922 born in London, lives in Northend

*Just what is it that makes today's homes so
different, so appealing?*, 1956
Collage
26 x 25 cm
Kunsthalle Tubingen, Collection Zundel
cat. 28 | fig. p.13

ARTURO HERRERA

1959 born in Caracas, Venezuela, lives in
Berlin and New York

Untitled, 1997/98
Mixed media collage on paper
30,5 x 22,9 cm
Owned by artist, courtesy Brent Sikkema,
New York
cat. 29 | fig. p.52

Untitled, 1997/98
Mixed media collage on paper
30,5 x 22,9 cm
Owned by artist, courtesy Brent Sikkema, New York
cat. 30 | fig. p.122

Untitled, 2002
Collage, tempera on paper
35,4 x 27,8 cm
Owned by artist
cat. 31

Untitled, 2002
Collage, tempera on paper
35,4 x 27,8 cm
Owned by artist
cat. 32

Untitled, 2002
Collage, tempera on paper
35,4 x 27,8 cm
Owned by artist
cat. 33

PIERRE HUYGHE
1962 born in Paris, lives in Paris

No Ghost Just a Shell: Two Minutes out of Time, 2000
Video, 5.1 surround system, 4 min.
Courtesy Galerie Marian Goodman, Paris
cat. 34 | fig. p.74

HIDEAKI KAWASHIMA
1969 born in Aichi, Japan, lives in Tokyo

Please, 2003
Acrylic on canvas
91 x 91 cm
Private collection, France
cat. 35 | fig. p.66

MIKE KELLEY
1954 born in Detroit, lives in Los Angeles

Missing Time Color Exercise #1, 1998
Acrylic on wood, magazines
89 x 117 cm
Private collection, courtesy Jablonka Galerie, Cologne
cat. 36 | fig. p.43

MARTIN KIPPENBERGER
1953 born in Dortmund, 1997 died in Wien

Untitled *(Passepartout für Polke-Graphik)*, 1993
Silkscreen, collage, reworked with acrylic and felt tip
100 x 80 cm
Collection Speck, Cologne
cat. 37 | fig. p.40

ROY LICHTENSTEIN
1923 born in New York, 1997 died in New York

Takka Takka, 1962
Magna on canvas
142 x 173 cm
Museum Ludwig, Cologne
cat. 38 | fig. p.21

Crying Girl, 1963
Offset lithograph
43,8 x 59 cm
Staatsgalerie Stuttgart/Graphische Sammlung
cat. 39 | fig. p.88

Crak!, 1964
Offset lithograph
Edn.: 123/300, signed, dated
47,4 x 68,6 cm
Staatsgalerie Stuttgart/Graphische Sammlung
cat. 40 | fig. p.89

Pow! Sweet Dreams, Baby!, 1965
Silkscreen
Edn.: 153/200 (from the portfolio 11 Pop Artists
Vol. III, 1965)
90,4 x 65 cm
Staatsgalerie Stuttgart/Graphische Sammlung
cat. 41 | fig. p.83

KERRY JAMES MARSHALL
1955 born in Birmingham, AL, lives in Chicago

Page layout for RYTHM MASTR #1–4, 1999
Indian ink on paper
Each 83,82 x 51,44 cm
Owned by artist, courtesy Jack Shainman
Gallery, New York
cat. 42a-d | figs. p.54/55

MATT MULLICAN
1951 born in Santa Monica, CA, lives in New York

Details from an Imaginary Universe, 1973
Collage of comic strips on paper
43 x 24 cm
Städtische Galerie im Lenbachhaus, Munich
cat. 43 | fig. p.34

TAKASHI MURAKAMI
1962 born in Tokyo, lives in Tokyo, Paris and
New York

*Homage to Francis Bacon (Study of Isabel
Rawsthorne)*, 2002
Acrylic on canvas on wood
120 x 120 x 5 cm
Courtesy Galerie Emmanuel Perrotin, Paris
© 2002 Takashi Murakami/Kaikai Kiki Co., Ltd. All
rights reserved.
cat. 44 | fig. p.70

Yupi, 2000
Acrylic on canvas on wood
100 x 100 cm
Courtesy Galerie Emmanuel Perrotin, Paris
© 2000 Takashi Murakami/Kaikai Kiki Co., Ltd.
All rights reserved.
cat. 45 | fig. p.73

YOSHITOMO NARA
1959 born in Hirosaka, Japan, lives in Tokyo

2004 Summer Drawings, 2004
Drawings
Courtesy Galerie Zink and Gegner, Munich
cat. 46 | figs. p.116–118

JULIAN OPIE
1958 born in London, lives in London

Bruce Walking, 2004
Computer animation, computer film,
40" LCD screen, PC, edn.: 4,1
Courtesy Galerie Barbara Thumm, Berlin
cat. 47 | fig. p.92

EDUARDO PAOLOZZI

1924 born in Edinburgh, lives in London

Bunk: Meet the People, 1948/72
Silkscreen, lithograph, collage
35 x 26 cm
Staatliche Museen zu Berlin, Kupferstichkabinett
cat. 48b | fig. p.15

Bunk: Real Gold, 1950/72
Silkscreen
32 x 24 cm
Staatliche Museen zu Berlin, Kupferstichkabinett
cat. 48a | fig. p.15

PHILIPPE PARRENO

1964 born in Oran, Algeria, lives in Paris

No More Reality, Batman Returns, 1993
Acrylic on vinyl balloon
Diameter 300 cm
Private collection, courtesy Esther Schipper, Berlin
cat. 49 | fig. p.72

No Ghost Just a Shell: Anywhere Out of the World, 2000
Video, 5.1 surround system, 4 min.
Musée d'Art Moderne de la Ville de Paris, Paris
cat. 50 | fig. p.75

RAYMOND PETTIBON

1957 born in Tucson, AZ, lives in Hermosa Beach, CA

Paper Nautilus, 1992
Artist's book, 46 pages, unique copy
Watercolour on hand-made paper
34,5 x 25,5 cm
Collection Speck, Cologne
cat. 51 | fig. p.44/45

Meow my fellow Americans (Vavoom book), 1994
Artist's book, 50 pages, unique copy
Pencil, coloured pencil and watercolour on paper
31,5 x 23,5 cm
Collection Speck, Cologne
cat. 52

Untitled *(There is your book)*, 1985
Ball-point pen, Indian ink on paper
44 x 36,5 cm (framed)
Collection of the Landesbank Baden-Württemberg
cat. 53

I'll outlast you f..ker, 1986
Indian ink on paper
44 x 36,5 cm (framed)
Collection of the Landesbank Baden-Württemberg
cat. 54

Vavoom, 1988
Indian ink on paper
66 x 51,5 cm (framed)
Collection of the Landesbank Baden-Württemberg
cat. 55 | fig. p.46

I imagined as I ..., 1992
Mixed media on paper
40 x 44 cm (framed)
Collection of the Landesbank Baden-Württemberg
cat. 56

Untitled *(Vavoom)*, 1992
Mixed media on paper
44 x 40 cm (framed)
Collection of the Landesbank Baden-Württemberg
cat. 57

From the clear blue sky, 1992
Indian ink, watercolour on paper
51 x 41 cm (framed)
Collection of the Landesbank Baden-Württemberg
cat. 58

The resulting consciousness, 1992
Indian ink on paper
46 x70 cm (framed)
Collection of the Landesbank Baden-Württemberg
cat. 59 | fig. p.46

Every world in him is ..., 1992
Indian ink and watercolour on paper
46 x 69 cm (framed)
Collection of the Landesbank Baden-Württemberg
cat. 60

Untitled *(An aerial and ...)*, 1993
Pencil, Indian ink on paper
69 x 46 cm (framed)
Collection of the Landesbank Baden-Württemberg
cat. 61 | fig. p.101

Untitled *(C'mon Ray)*, 1993
Pencil, Indian ink on paper
65 x 48 cm (framed)
Collection of the Landesbank Baden-Württemberg
cat. 62

Untitled *(A red carpet had ...)*, 1993
Ball-point pen, Indian ink on paper
44 x 36,5 cm (framed)
Collection of the Landesbank Baden-Württemberg
cat. 63 | fig. p.101

Untitled *(The impersonal author's ...)*, 1993
Ball-point pen, Indian ink on paper
44 x 39,5 cm (framed)
Collection of the Landesbank Baden-Württemberg
cat. 64

SIGMAR POLKE
1941 born in Oels/Silesia, lives in Cologne

Lucky Luke and His Friend, 1971-75
Acrylic and oil on canvas
2 sections, each 130 x 110 cm
Collection Lergon
cat. 65 | fig. p.86/87

MEL RAMOS
1935 born in Sacramento, CA, lives in Oakland,
CA and Horta de San Juan, Spain

Captain Midnight, 1962
Oil on canvas
58,4 x 66 cm
Mel Ramos
cat. 66 | fig. p.113

The Flash, 1962
Oil on canvas
86,4 x 45,7 cm
Mel Ramos
cat. 67 | fig. p.17

Batman, 1961
Oil on canvas
86,4 x 61 cm
Mel Ramos
cat. 68 | fig. p.18

ALEXANDER ROOB
1956 born in Laumersheim, lives in Düsseldorf
and Stuttgart

Auto Mainz-Celle, 1999
Pencil on paper
2 frames each containing 5 drawings,
each 22,5 x 113,5 (framed)
Staatsgalerie Stuttgart/Graphische Sammlung
cat. 69 | figs. p.64/65

DIETER ROTH
1930 born in Hannover, 1998 died in Basel

BOK 3 b, 1961–66
Edn.: 9/50 (10 of which produced)
Artists' book, approx. 250 pages, bound
18 x 18 cm
Staatsgalerie Stuttgart, Archiv Sohm
cat. 70 | fig. p.38

WILHELM SASNAL
1972 born in Tarnów, Poland, lives in Tarnów, Poland

Maus, 2001
Oil on canvas
110 x 130 cm
Owned by artist
cat. 71 | fig. p.84

Maus, 2001
Oil on canvas
190 x 190 cm
Owned by artist
cat. 72 | fig. p.85

Maus, 2001
Oil on canvas
50 x 40 cm
Owned by artist
cat. 73 | fig. p.84

Maus, 2001
Oil on canvas
90 x 190 cm
Privately owned by Dr. Isabella Johnen
cat. 74

DOROTHEA SCHULZ
1962 born in Karlsruhe, lives in Stuttgart

victoire, je suis encore au lit, 2004
Ink jet print on paper
Each 240 x 112 cm
Owned by artist
cat. 75 | fig. p.64

DAVID SHRIGLEY

1968 born in Leicester, lives in Glasgow

Untitled *(Today my heart is filled)*, 2003
Indian ink on paper
30 x 21 cm
Collection DuMont Schütte
cat. 76 | fig. p.97

Untitled *(Labels on bottles)*, 2003
Indian ink on paper
30 x 21 cm
Collection DuMont Schütte
cat. 77

Untitled *(Dear mother, I do not like)*, 2003
Indian ink on paper
30 x 21 cm
Collection DuMont Schütte
cat. 78 | fig. p.97

Untitled *(Bird on a wire getting ...)*, 2003
Indian ink on paper
30 x 21 cm
Collection DuMont Schütte
cat. 79

Untitled *(Seizure at the beauty)*, 2003
Indian ink on paper
30 x 21 cm
Collection Dr. Werner Peters, Cologne
cat. 80

Untitled *(How much does it cost)*, 2003
Indian ink on paper
30 x 21 cm
Courtesy Collection Bruni and Wolfgang Strobel
cat. 81 | fig. p.60

Untitled *(Hairbrush)*, 2003
Indian ink on paper
30 x 21 cm
Courtesy BQ, Cologne
cat. 82

Untitled *(Biog.)*, 2003
Indian ink on paper
30 x 21 cm
Courtesy BQ, Cologne
cat. 83

Untitled *(I have done my best)*, 2003
Indian ink on paper
30 x 21 cm
Courtesy BQ, Cologne
cat. 84

Untitled *(Today's menu)*, 2003
Indian ink on paper
30 x 21 cm
Courtesy BQ, Cologne
cat. 85

Untitled *(Figure lying on back with spiders)*,
2003
Indian ink on paper
30 x 21 cm
Private collection, Switzerland
cat. 86 | fig. p.96

Untitled *(Figure looking out of cell)*, 2003
Indian ink on paper
30 x 21 cm
Private collection, Switzerland
cat. 87 | fig. p.61

THADDEUS STRODE

1964 born in Santa Monica, CA, lives in
Pasadena, CA

Don't Mind, Don't Smell Bleaching, 1994/96
Mixed media on canvas
180 x 150 cm
Collection Speck, Cologne
cat. 88 | fig. p.100

*Pop Song #2: Everything Happens, Follow
the Pattern*, 1997
Acrylic and felt tip on canvas
220 x 271 cm
Collection Falckenberg, Hamburg
cat. 89 | fig. p.47

Thought Bubble, 1993
Mixed media on paper
61 x 48 cm
Courtesy neugerriemschneider, Berlin
cat. 90

Ka (shape), 1995
Mixed media on paper
61 x 50,5 cm
Courtesy neugerriemschneider, Berlin
cat. 91

Wild West, 2001
Mixed media on paper
51 x 33 cm
Courtesy neugerriemschneider, Berlin
cat. 92 | fig. p.99

I am a Stone, 2001
Mixed media on paper
37 x 28 cm
Courtesy neugerriemschneider, Berlin
cat. 93

Stories and Words, 2002
Mixed media on paper
51 x 66 cm
Courtesy neugerriemschneider, Berlin
cat. 94 | fig. p.98

HERVÉ TÉLÉMAQUE

1937 born in Port-au-Prince, Haiti, lives in Paris

One of the 36 000 Marines over our Antilles,
1965
Oil on canvas
160 x 357 cm
Courtesy Kunstverein Braunschweig
cat. 95 | fig. p.26/27

JOHN WESLEY

1928 born in Los Angeles, lives in New York

Olive Oyl, 1973
Acrylic on canvas
144,78 x 185,42 cm
Private collection, Switzerland
cat. 96 | fig. p.22

B's town, 1973/74
Acrylic on canvas
106 x 193 cm
Collection Onnasch
cat. 97 | fig. p.23

SUE WILLIAMS

1954 born in Chicago Heights, IL, lives in
New York

Real Fur Hat, 1995
Oil on canvas
38 x 45,7 cm
Galerie Eva Presenhuber, Zurich
cat. 98 | fig. p.49

Animal Husbandry, 2002
Indian ink on vellum
101,6 x 180,3 cm
LAC - Switzerland
cat. 99 | fig. p.48

VADIM ZAKHAROV

1959 born in Duschambe, USSR, lives in Cologne

*Wörterbuch des nonverbalen Wortschatzes
mit Kommentaren (Erster Teil: Die Welt der
Comicgeräusche von Vadim Zakharov und
Daniel Zakharov)*, 2001
Artist's book, edn.: 20
30,5 x 22 cm
Vadim Zakharov
cat. 100 | fig. p.57

COLOPHON

This catalogue accompanies the exhibition
*Funny Cuts. Cartoons and Comics
in Contemporary Art.*
Staatsgalerie Stuttgart,
4th December 2004–17th April 2005

Exhibition and catalogue: Kassandra Nakas
Essay by Ulrich Pfarr and Andreas Schalhorn

Design: Cluss | Galli
Typesetting: Baltus Mediendesign, Bielefeld
Lithography: Klaus-Peter Plehn, Kerber Verlag
Translations: Jeremy Gaines, Frankfurt am Main
Copy-editing: Eileen Laurie, Derry

Printed and published by
Kerber Verlag, Bielefeld
Windelsbleicher Str. 166–170
D-33659 Bielefeld
Tel. +49 (0) 5 21/9 50 08 10
Fax +49 (0) 5 21/9 50 08 88
e-mail: info@kerber-verlag.de
www.kerber-verlag.de

US Distribution
D.A.P., Distributed Art Publshers Inc.
115 Sixth Avenue 2nd Floor
New York, NY 10013
Tel. (001) 212 627 19 99
Fax (001) 212 627 94 84

Cover illustration: Mel Ramos, *The Flash,* 1962 (cat. 67), © 2004 VG Bild-Kunst, Bonn
Frontispiece: Yoshitaka Amano, *Landing,* 2002 (detail), cat. 1

Photo Credits: Volker Naumann, Dirk Kittelberger, Gerhard Ziller, Staatsgalerie Stuttgart (pp. 24, 32/33, 37, 64/65, 83, 88, 89, 91, 116–118); Olaf Bergmann (pp. 50/51); Achim Kukulies (pp. 62/63, 100), © Städtische Galerie im Lenbachhaus, Munich (pp. 30, 34); © Staatliche Museen zu Berlin, Kupferstich- kabinett, photographer: Jörg P. Anders (p. 15); © Photo CNAC/MNAM Dist. RMN/ © Photo Philippe Migeat (p. 36); © Courtesy Air de Paris (p. 74); courtesy Esther Schipper, Berlin (p. 72); courtesy Jack Shainman Gallery, New York (pp. 54/55); courtesy Galerie Eigen und Art, Leipzig/Berlin (pp. 77, 127); courtesy Galerie Eva Presenhuber, Zurich (p. 49); courtesy Jablonka Galerie, Cologne (p. 43); courtesy Galerie Zink und Gegner, Munich (pp. 116–118); courtesy Julian Opie and Galerie Barbara Thumm (p. 92); courtesy Galerie BQ, Cologne (pp. 60/61, 96/97); all other photographs are from the archives of the persons and institutions who have lent works to the exhibition.
© 2004 VG Bild-Kunst, Bonn for the works of Peter Blake, Tim Eitel, Erró, Öyvind Fahlström, Richard Hamilton, Roy Lichtenstein, Bruce Nauman, Eduardo Paolozzi, Mel Ramos, Alexander Roob, Hervé Télémaque; © fam. Jorn/VG Bild-Kunst, Bonn 2004 for the works of Asger Jorn.
© 2004 Estate Dieter Roth, Zurich; © 2004 Estate Martin Kippenberger, Galerie Gisela Capitain, Cologne; © 2004 Estate of Keith Haring; © 2004 Andy Warhol Foundation for the Visual Arts/ARS New York.
Unless otherwise stated copyright for the photographs remains with the respective artist or his/her legal successor.

© 2004 Staatsgalerie Stuttgart; Kerber Verlag, Bielefeld; the authors and photographers

ISBN 3-938025-01-8

The German edition is available under
ISBN 3-936646-95-3

Printed in Germany

Stiftung
Landesbank-Baden-Württemberg
LB≡BW